JOSÉ CLEME

PROME

NTE OROZCO

THEUS

Edited by

Marjorie L. Harth

Pomona College Museum of Art

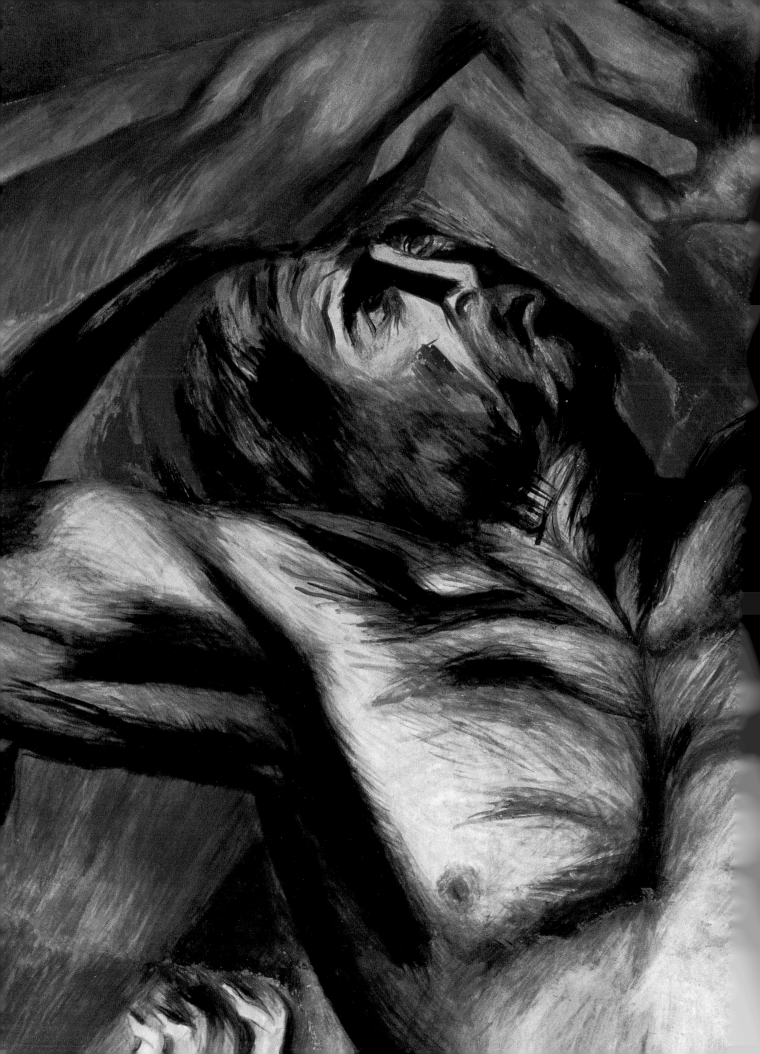

Contents

Prefatory Remarks

RENAISSANCE HUMANISTS believed that the highest form of knowledge was that which concerned the nature of the human community, its dilemmas and possibilities. The pursuit of such wisdom taught men and women not only to think but to act, not only to appreciate but to emulate, not only to know but to carry on a creative dialogue with the past that would inform learning beyond their own time. They held, further, that education should prepare people to lead a good life; that it should have breadth; that its function was to shape the will as well as the intellect; and that humanistic scholarship should be directed to those purposes. Every time I see the *Prometheus* I imagine Orozco thinking along the same lines of earlier humanists as he painted his magnificent work on the walls of Pomona College.

In my youth, family friends took me to see the mural. I returned on my own on several occasions. In my wildest imagination, I never dreamed I would be involved in contributing to its further understanding and wider appreciation. Yet art is always an adventure, as evidenced by the long and challenging journey of returning Orozco's preparatory drawings to their rightful place at Pomona College, guided by the dedication and perseverance of many and led by the joyous spirit and resolute determination of Marjorie Harth.

Sound scholarship requires continuing reflection and debate in light of the questions and opportunities created by new knowledge, new conditions, new needs, and new generations of students and teachers alike. And even if the dilemmas turn out to be old ones, we need to make them our own, to identify the enduring questions within the context of our day. Having Orozco's original studies for the *Prometheus* accessible to scholars, students, and a diverse public is a remarkable achievement that symbolizes the singular role that art and education play in society.

MIGUEL ANGEL CORZO
President, The University of the Arts, Philadelphia, Pennsylvania

ONE OF THE MOST IMPORTANT and distinctive characteristics of the Mexican muralists (Rivera, Orozco, Siqueiros) is that although they were essentially a nationalistic movement that was even, on occasion, chauvinistic, their formation and much of their work took place outside of Mexico. This fact undoubtedly contributed to the establishment over the years of the Mexican artistic presence abroad, particularly in the United States.

Some of these murals were censored and even destroyed. And, in some, political content carried more weight than artistic value. Nevertheless, many of them were protected and cared for. Especially those works that happened to be in academic institutions found a welcome home among a public whose sensitivity and intellectual predilection kept them from joining those who barbarously attempted to eradicate these testimonies to the world's social and political diversity.

The passage of time inevitably caused physical deterioration of these works, especially where artists were experimenting with new materials and techniques. And their fragility and vulnerability to the environment and the public added to the hazards of political and social incomprehension. Nevertheless, time has also allowed for reevaluation, not only of the aesthetic value of the murals but also of nearly all the artistic output of these painters, who with the passing of the years have today acquired widespread recognition that extends beyond political circumstances.

The murals painted on the walls throughout the length and breadth of Mexico fulfilled an essential pedagogical function. They were used to illustrate chapters in the history of Mexico and of humanity, and to make these chapters accessible to all. In addition to their intrinsic artistic value, the murals acquired a profound significance for the spectators who saw reflected in them their own origin and common history.

The fact that the *Prometheus* mural is located at Pomona College in the city of Claremont in an academic institution reflects the interest of the College that shelters it as much as the desire of the painter to be near young people and share with them his art and vision of history. As a lover of Mexican art, I celebrate Pomona College's efforts to maintain and preserve this great work. This commitment confirms the depths of the social and aesthetic ties that we share.

I am sure that the young people who attend this College will continue living with Orozco and learning through his achievement that art is a universal language.

GERARDO ESTRADA
Director General for International Cultural Cooperation, Ministry of Foreign Affairs, Mexico

Prometheus

Titan! to whose immortal eyes
 The sufferings of mortality,
 Seen in their sad reality,
Were not as things that gods despise;
What was thy pity's recompense?
A silent suffering, and intense;
The rock, the vulture, and the chain,
All that the proud can feel of pain,
The agony they do not show,
The suffocating sense of woe,
 Which speaks but in its loneliness,
And then is jealous lest the sky
Should have a listener, nor will sigh
 Until its voice is echoless.

Titan! to thee the strife was given
 Between the suffering and the will,
 Which torture where they cannot kill;
And the inexorable Heaven,
And the deaf tyranny of Fate,
The ruling principle of Hate,
Which for its pleasure doth create
The things it may annihilate,
Refus'd thee even the boon to die:
The wretched gift Eternity
Was thine—and thou hast borne it well.
All that the Thunderer wrung from thee
Was but the menace which flung back
On him the torments of thy rack;
The fate thou didst so well foresee,
But would not to appease him tell;
And in thy Silence was his Sentence,
And in his Soul a vain repentance,
And evil dread so ill dissembled,
That in his hand the lightnings trembled.

Thy Godlike crime was to be kind,
 To render with thy precepts less
 The sum of human wretchedness,
And strengthen Man with his own mind;
But baffled as thou wert from high,
Still in thy patient energy,
In the endurance, and repulse
 Of thine impenetrable Spirit,
Which Earth and Heaven could not convulse,
 A mighty lesson we inherit:
Thou art a symbol and a sign
 To Mortals of their fate and force;
Like thee, Man is in part divine,
 A troubled stream from a pure source;
And Man in portions can foresee
His own funereal destiny;
His wretchedness, and his resistance,
And his sad unallied existence:
To which his Spirit may oppose
Itself—and equal to all woes,
 And a firm will, and a deep sense,
Which even in torture can descry
 Its own concenter'd recompense,
Triumphant where it dares defy,
And making Death a Victory.

Diodati, July 1816

George Gordon,
Lord Byron, 1788-1824

Foreword and Acknowledgments

THE FRESCO THAT JOSÉ CLEMENTE OROZCO painted in 1930 at Pomona College was both the artist's first work in the United States and the first Mexican mural in this country. As such, the *Prometheus* is a landmark in the history of the Mexican mural movement and of the art of the twentieth century. This is a point of justifiable pride for Pomona College, reflecting remarkable courage and foresight on the part of those responsible for the commission. The status of being first, however, is circumstantial, and, in the final analysis, insufficient to guarantee lasting significance. A better measure of greatness, I believe, is the degree to which a work of art continues to invite and reward contemplation, response, and interpretation. The four scholarly essays in this volume, written over a period of forty three years, bear eloquent testimony to the undimmed power of the *Prometheus* to intrigue, provoke, and inspire.

It is a rare privilege to be able to include early as well as contemporary scholarship in a monographic study. For this I am indebted to David W. Scott, whose seminal 1957 *Art Journal* essay is reprinted here. The first scholarly work to be published on the *Prometheus*, it remains central to Orozco scholarship, the gold standard by which all writings about the mural must be judged. Scott's second essay, adapted by the author from lectures delivered at Dartmouth College, and later in Claremont in the 1980s, gives us the benefit of a scholar's vision over time of the work of art that, as he writes, he has always considered his "touchstone of greatness." At the other end of the spectrum, the essays by Mary K. Coffey and Renato González Mello, both written for this occasion, bring to the interpretation of the mural the richness of recent academic thought and scholarship. In the intervening years, countless others have been drawn to think and write about the *Prometheus*, and there is every reason to believe that future generations will continue to do so.

The publication of this book was prompted in part by the acquisition in

2000 of seventeen preparatory drawings for the mural that belonged to the artist's family. The success of this quest, under way since the 1950s, is due to a great many individuals. It was the desire of Orozco's three children—Clemente, Lucrecia, and Alfredo Orozco Valladares—to see the *Prometheus* drawings united with the mural that led ultimately to their decision to part with them. We are enormously grateful to every member of the Orozco family who participated in this effort. The donations to Pomona College that provided acquisition funds were made by Walter and Elise Mosher between 1959 and 1970. From the day our offer to the Orozco family was accepted, Miguel Angel Corzo, President of The University of the Arts in Philadelphia, has been my guide. It was he, along with his colleague in Mexico, Rosalia Navarro, who helped us obtain an export permit, personally interceding on our behalf and arranging an introduction to Gerardo Estrada, then director of the Instituto Nacional de Bellas Artes, who issued the required permissions. Miguel Angel has continued to offer such indispensable assistance (including editing advice on the Spanish edition of this book) that I honestly cannot imagine how either the acquisition or publication could have been accomplished without him.

The publication date of this book, originally scheduled for 2002, was moved up a full year in order to make it available at the time of the major exhibition of Orozco's work in the United States organized by Dartmouth College in collaboration with the Museo de Arte Álvar y Carmen T. de Carrillo Gil and the Instituto Nacional de Bellas Artes in Mexico City. To meet this revised timetable has required a great deal of effort, and I am grateful to everyone who has rallied to the cause. This pertains particularly to Tish O'Connor and Dana Levy of Perpetua Press, Los Angeles and Santa Barbara, whose enormous talent and reassuring grace under pressure have been a godsend. At Dartmouth, Diane Miliotes has been extraordinarily helpful in every respect. For assistance with the always difficult process of obtaining illustrations and reproduction permission, I am indebted to José Luis Pérez Arredondo and Armando Rodriguez Fletcher, Banco de México; Veronica de la Rosa Jaimes, Instituto Nacional de Bellas Artes, Mexico City; Patti Junker and Courtney de Angelis, Amon Carter Museum, Fort Worth; Kathleen O'Malley, Hood Museum, Dartmouth College; Sherri Sarantakis, Stock Exchange / Tower Associates, San Francisco; Bob Schalkwijk, Mexico City; Eumelia Hernández Vázquez, Archivo Fotográfico, Instituto de Investigaciones Estéticas, Universidad Autónoma de México; and Nina Zurier, San Francisco Art Institute.

This project has depended heavily upon the support of a great many of my colleagues at Pomona College. In particular, I would like to acknowledge Trustee J. Patrick Whaley (Class of 1956) who first put me in touch with Miguel Angel Corzo; President Peter W. Stanley and Dean Hans C. Palmer for both financial and moral support; Donald M. Pattison for his masterful editorial skills, creative solutions, and unending encouragement; Howard Young for reviewing the Spanish translations; Sara Mitchell for serving as translator and interpreter during the

negotiations for the drawings; Michael Balchunas for extensive proofreading; Susan Coerr for creating the index; and Jean Beckner and Carrie Marsh at Honnold Library for their superb research assistance. Every member of the Museum's staff—Steve Comba, Rebecca McGrew, Barbara Senn, Katie Horak— has played a crucial role in this endeavor, and I am particularly indebted to Elizabeth Villa '92, surely the most versatile and resourceful research assistant imaginable. Publication funds were provided by the Office of the President and The Rembrandt Club, Pomona College; The James Irvine Foundation; private contributions from Museum Advisory Committee members Edith Bergstrom '63 and Andrew Sloves '85; and anonymous donors.

As anyone who has been involved in a complex, long-term endeavor will understand, acknowledgments like these are wholly inadequate to convey the gratitude one feels to those who have made its accomplishment possible. Orozco's *Prometheus* has played a role in my life for over twenty years. I have always considered it a privilege to be responsible in some measure for so important a work of art, and it is extraordinarily gratifying to have been able to participate in the acquisition of the preparatory drawings and the publication of this monograph. To all those who have shared these dearly held goals with me for so many years, I extend grateful thanks that mere words can never express.

MARJORIE L. HARTH
Director, Pomona College Museum of Art

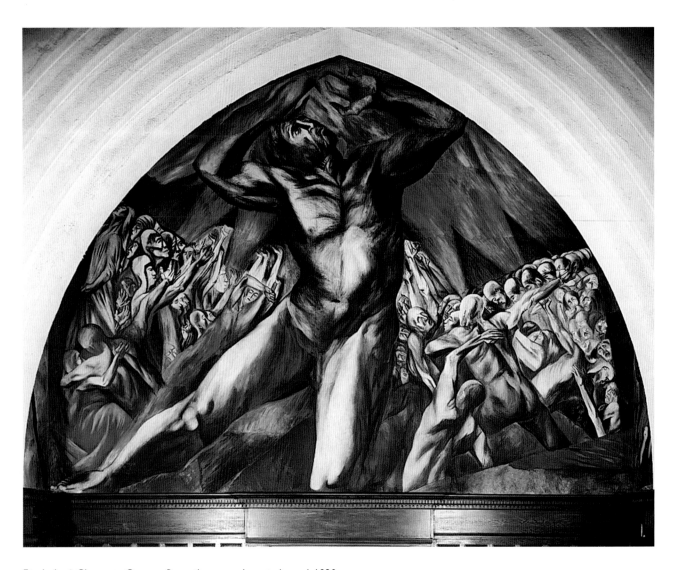

Fig. 1. José Clemente Orozco, *Prometheus* mural, central panel, 1930,
Pomona College, Claremont, California.

Orozco's *Prometheus*

Summation, Transition, Innovation

by DAVID W. SCOTT

*If new races have appeared upon the lands of the New World, such
races have the unavoidable duty to produce a New Art in a new spiritual
and physical medium. Any other road is plain cowardice.*[1]

—José Clemente Orozco, 1929

*David W. Scott grew up in
Claremont, the son of a Pomona
College professor. Although in 1930
Scott lived within four blocks of
Frary Hall, where José Clemente
Orozco was painting* Prometheus,
*he was unaware of the mural until
his college years, when he discovered
art and decided to become a
painter. After college, art school and
service in the war, he returned to
Claremont to teach painting and art
history at Scripps College. Several
summers in Mexico piqued his
curiosity about* Prometheus *and its
place in Orozco's work and Mexican
art of the time. After looking in vain
for the painter's earliest work—
magazine illustrations—in Mexico,
he discovered them close to home,
in a store of Mexican periodicals
being offered for sale to Honnold
Library in Claremont. From these,
which included Orozco's earliest
published drawings, Scott traced the
development of the artist's formative
work and wrote this article,
"Orozco's* Prometheus: Summation,
Transition, Innovation," *published in
the* College Art Journal, *vol. XVII,
no.1, 1957. It is reprinted here with
the permission of the author and
the College Art Association.*

N JUNE 1930, JOSÉ CLEMENTE OROZCO finished the first
Mexican fresco to be painted in the United States.[2] In at least one
fundamental sense, the *Prometheus* at Pomona College
(Claremont, California) was the first major "modern" fresco in
this country and thus epochal in the history of the medium. It re-
vealed a new concept of mural painting, a greatly heightened direct and personal
expression. It challenged accepted conventions, which decreed that wall decora-
tion should be flat and graceful, pleasant, decorous, and impersonal. In the
Prometheus, Expressionism achieved a monumental scale.

The Claremont fresco was daringly advanced in style and may be taken as
marking a new phase in the history of mural painting. Yet the preceding ten
years had not been without extensive activity; they had witnessed well publi-
cized efforts of John Singer Sargent, Augustus Vincent Tack, Eugene Savage, Jules
Guerin, and Violet Oakley. Hugh Ballin had devoted himself intensively to the
mural in the Los Angeles area since 1928. In that same year Ray Boynton painted
his strikingly simplified and decorative Mills College frescoes, termed the first
work in the medium on the walls of a public building in the West.

In 1930, the tempo of activities quickened; a quantitative and qualitative
change set in. In February the project for a Mural Hall at the Los Angeles
County Museum culminated in an international competition and the exhibition
of 74 designs.[3] In the course of the year, Boardman Robinson began work in
Pittsburgh and Thomas Hart Benton in New York City. Five months after the
Prometheus was finished, Diego Rivera arrived in San Francisco. By this time, mural
painting in America had entered a new stage in its development; its most advanced
manifestation was to be found in Claremont, California.

The effectiveness and force of the *Prometheus* have been recognized. Less
appreciated is the significant place it may claim in the development of Orozco's
work in particular and of American art in general. It formed a summation of much
of Orozco's earlier work, including his first mural phase; it provided a transition

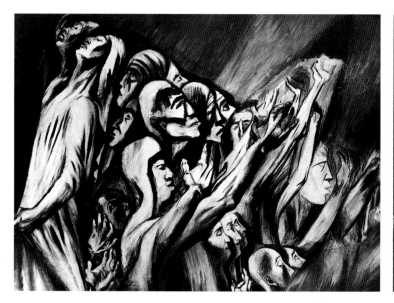 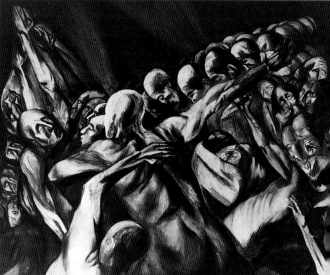

Fig. 2. *Prometheus*, detail of left side of central panel: the crowd.

Fig. 3. *Prometheus*, detail of right side of central panel: the crowd.

to his fully mature style; and as it introduced new elements into his fresco painting, it became simultaneously a momentous innovation in our entire concept of wall decoration.

* * *

The central subject of the mural is the exploit of Prometheus, the giant of Greek mythology who stole fire from the gods to give to mankind and whose fate is described in the tragedy of Aeschylus. Since the gift of fire symbolizes the concern of an educational institution, this subject is not inappropriate. The classic myth is portrayed on the walls of a college that bears the name of a Roman goddess. However the theme was hit upon,[4] it was one that would have appealed to Orozco in the first weeks of the year 1930. His association with Greek intellectuals and nationalists in New York had filled his mind with images of their country and culture. His friends Alma Reed and Eva Sikelianos had been concerned with the project of staging Aeschylus's *Prometheus Bound* at Delphi in 1929.

The Claremont fresco stands in a shallow stage-like recess at the north end of Frary Hall, the large refectory of the Eli P. Clark Men's Dormitory at Pomona College. The recess is framed by a pointed arch. As one enters the hall opposite the fresco, this arch masks the outer edges of the main panel and the adjoining areas. Seen close at hand and within the arch, the composition extends from the main wall (which is gable-shaped at top) forward on the inclined ceiling surfaces and on the two narrow lateral walls of the recess.

The great central panel shows the colossal form of the nude Titan, fallen on one knee, in the act of bringing the living flame from heaven with his bare hands (fig. 1). Fire radiates over the hordes of mankind that surge about his legs. The varied effects of the gift on different groups of men are indicated by dramatic gestures and colors. They portray eager acceptance, indifference, prostration, and outright rejection (figs. 2–3).

From the hall it appears as if Prometheus is grasping heavenward behind the arch. If one approaches and looks at the ceiling adjacent to his hands (fig. 4),

he sees a curious symbol of interlocking, flame-darting rectangles. The reference of this device, which at first seems obscure, is to an abstractly conceived Godhead, the source of the Fire.

The side wall to the right shows centaurs in attitudes of despair and agony (figs. 6–7). A female centaur, in the coils of a huge serpent, rears violently, while her baby throws up imploring arms. Orozco himself described the panel as representing "the ancient times that Prometheus is upsetting by giving knowledge to man."[5]

On the side wall opposite (fig. 5), seeming to stare forth from a cosmic tempest, are symbolic forms representing Zeus, Hera, and Io. Their gaze is concentrated on the exploit of Prometheus.

<p align="center">* * *</p>

A foremost Latin American critic has remarked that Prometheus serves as Orozco's totemic symbol—that scattered references to the theme occur in all his painting, and that these appear gathered together and developed most fully in the fresco at Pomona College.[6] It is true that we may trace the thematic elements—the giant, the crowd, the fire—through some of Orozco's earlier work. Not only the subject elements but also some of the formal and stylistic aspects of the painting go far back, back in many cases to Orozco's student days in the first years of the century.

Indeed, it is not a strained interpretation to see in the Prometheus figure Orozco himself—the isolated artist, struggling titanically, consumed by the very creative gift he brings to man, received by an indifferent or hostile crowd. "Destroying and creating, he suffers. He has the habit of pain," Anita Brenner wrote of Orozco in 1927.[7] Eleven years before, in his first surviving public statement, he described his condition modestly but with a touch of Promethean heroism. He had no job, he said, and no resources; each sheet of paper and each tube of paint represented a sacrifice and a suffering; the public was hostile; but he was determined to add one grain of sand to the future monument of national art.[8] In yet another manner Prometheus recalls Orozco: the figure with his flaming hands near his anguished face strangely symbolizes the boy in his early teens who lost his left hand and damaged his eyesight as the result of a gunpowder explosion.

<p align="center">* * *</p>

By the year 1906,[9] when he was twenty-three, Orozco had begun his intensive association with the Academy of San Carlos. As a child he had drawn there in night classes, but subsequently he had studied agriculture at San Jacinto and then attended the National Preparatory School with "the vague intention of studying architecture later."[10] The period between 1906 and 1910 marked Orozco's principal experience at the Academy, where he was exposed to all the currents that centered on that focal point of Mexican art life of the time. These currents may be variously traced by a study of casts and records remaining at the building, a scrutiny of Orozco's *Autobiografía*, and a survey of the illustrated periodicals of the day—especially the *Revista Moderna* and *El Mundo Ilustrado*.

The cast room at the Academy reminds us, with its Greek, Roman, and

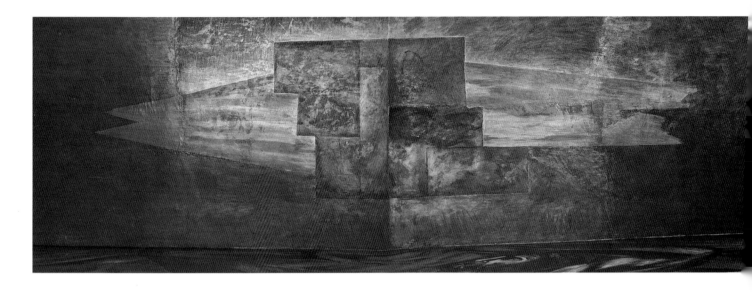

Fig. 4. *Prometheus*, ceiling panel, detail of Godhead symbol.

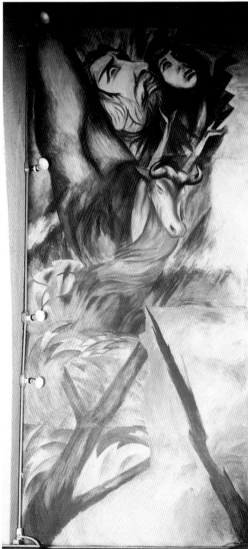

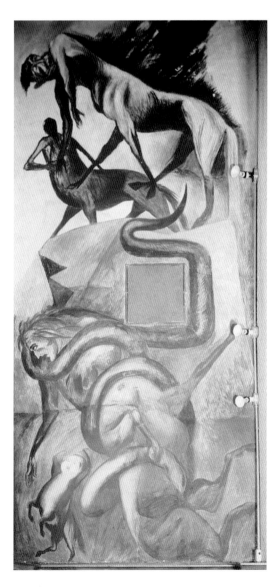

Fig. 5. *Prometheus*, left lateral panel: Zeus, Hera and Io.

Fig. 6. *Prometheus*, right lateral panel: centaurs in despair and agony.

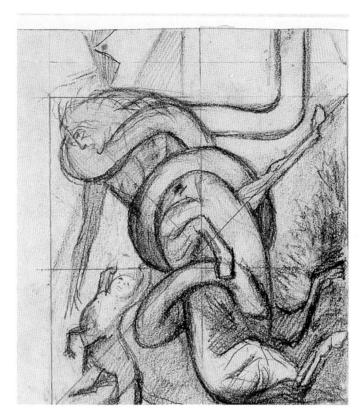

Fig. 7. Study for centaur panel, pencil, 1930.

Renaissance subjects, of the figure of Prometheus; more than once, but especially in the *Laocoön*, one may find prototypes for the gestures of the limbs, the heavily muscled torso, and the tortured, bent head. In Orozco's day it was part of every student's discipline to learn to draw the casts not only forward and backward but even upside down. Classic figures became part of the vocabulary of the young artists: in a decorative heading drawn in 1906 (fig. 8), Orozco built his design around the *Victory of Samothrace*.[11]

The professors of the Academy stressed carefully drawn and modeled representations of the classic or "natural" form; Gerardo Murillo (Dr. Atl) encouraged the young artists to strive for expressive exaggeration. His impact (which was felt at least as early as 1907) has been described by Orozco in the *Autobiografia*:

> The drawings which Atl made were of muscular giants in violent actions like those of the Sistine. The models which we copied were obliged to appear like the condemned from the *Last Judgement*.[12]

In 1910 the group about Atl came within a short step of launching the Mexican mural movement more than ten years early. The painters had received permission to paint the walls of the Anfiteatro Bolívar and were making active preparations when the Revolution threatened. Thus Orozco tells us clearly that by 1910 he was doing muscular giants after Michelangelo and was thinking of murals. We have the record of a significant precedent for the huge, heavily muscled figures of his first frescoes of 1923, and also suggestions of the form of Prometheus himself.

Even before he fell under the spell of Atl, Orozco had been influenced by the Mexican artist Julio Ruelas (1870–1907) and by the Modernista movement

Fig. 8. Orozco: Heading for article by "Okusai" (pseudonym for J. J. Tablada?), *El Mundo Ilustrado*, Jan. 1, 1907.

reflected in the pages of the *Revista Moderna* (1898–1911).[13] Ruelas's work is well recorded in the magazine. The "painter of cadavers, satyrs, hanged men, ghosts of suicidal lovers"[14] reveals, in spite of his romantic idiom, a quality which related him to Orozco—"a grave and skeptical melancholy,"[15] as Tablada was to express it. Orozco's own cadavers and hanged men are depicted in the terms of a more violent and direct age, but they were the expression of a somewhat kindred spirit; both artists were *atormentados*.

It is clear from the *Autobiografia* that Orozco knew Ruelas's work and that it had impressed him. I believe it helps us understand the formation of the thematic idiom of the *Prometheus* to remember that Ruelas employed the symbolism of classic mythology and that he had portrayed himself as a hanged satyr in a picture in which his friends appeared as serpents, centaurs, etc. The centaur or the satyr stood as a symbol of the natural or instinctive man, the artist. The satyr hanged or the centaur drowned became the artist who suffered! The same language was employed in *La Plume*, the French Symbolist magazine that was in many ways the prototype of the *Revista Moderna*. But Ruelas derived more directly from Boecklin, whom he had admired as a student in Germany. (He was not alone in this trend: "In all works of Mexican artists the influence of the modern German Symbolists is visible and undeniable," wrote José Francés in 1909.[16]) Struggling and wounded centaurs were themes Ruelas shared with Boecklin and von Stuck. The last-named artist was several times referred to in the *Revista*, and in November, 1906, a group of his works appeared, including his famous *Sin*, a woman's body in coils of a huge serpent.[17] Was it a memory of these subjects that suggested the motive of the right side panel at Claremont (fig. 6)?

The *Revista Moderna* group, as I have said, greatly admired the Symbolist organ, *La Plume*. A glance at the decorations of the Mexican magazine reveals that from the years 1900 to 1904 there was a change in formal means that might well be described as resulting from an interest in an abstract symbolism of shape. Obvious influences entered from Art Nouveau, Rodin, Beardsley, Japanese Art, etc. In 1907 an article by the young painter Angel Zárraga (1886–1946) expressly states that "the direction of a line may suggest an idea, and…each color…has its own character in relation to our sentiments."[18] The formulation of such ideas prepares the way for Orozco's expressions ranging from his *House of Tears* series of about 1913 to his *Prometheus* and after. They are reflected in the Godhead symbol on the ceiling at Claremont (fig. 4), and the 1947–48 mural in the open-air theater at the National Normal School in Mexico City.[19]

Close on the heels of the romantic-symbolist movement in Mexican art came an expressionist development. The two styles, of course, were related; but the first appears most clearly in the *Revista Moderna,* and the second, in *El Mundo Ilustrado*. In this latter periodical, in 1906 and 1907, Orozco appears as an illustrator and draftsman alongside Alberto Garduño and Carlos Alcalde, just when

Fig. 9. Orozco: Illustration for "La Segadora de Espenglos" by Ernest Gaubert, from *El Mundo Ilustrado*, Jan. 14, 1906.

these men were experimenting boldly with expressionist distortions. Orozco's very early illustrations (fig. 9) betray a timid and inexperienced hand, but they also reveal signs of Modernist and Expressionist influences.[20]

It is possible to trace Orozco's work fairly clearly in the second decade of the century. In the main, it divides into three groups: cartoons, drawings of schoolgirls, and paintings of prostitutes. Orozco worked intermittently for many years as a newspaper cartoonist, and the experience clearly led to his increasingly direct, freely calligraphic style. The "direct" expression of the cartoons and their bold distortions were qualities which he was only gradually to synthesize into his murals, however. They do not appear in their full power until the *Prometheus*.

On the other hand, the *House of Tears* series reveals that Orozco achieved a remarkably original style by about 1913. In these pictures a restrained, flattened manner is joined to a biting, caricature-like draftsmanship. The result may be called the first complete synthesis of "modern" painting in Mexico.[21] The composition is based on silhouetted forms, seldom overlapping, like that of the side panels at Claremont. The most important steps that Orozco took in 1913, however, were the assimilation of distorted and calligraphic elements to a serious style and the development of personal symbolic language for describing humanity directly and in the raw. Distinctly, cruelly individualized, the women yet began to merge into the Masses.

By the beginning of the third decade of the century, Orozco was possessed of at least the seeds of most of the ideas and forms that characterize the *Prometheus*. The story of the twenties is chiefly one of selection and growth. The artist himself insisted specifically upon the importance of the preparatory period:

> Mural painting encountered a set table in 1922. The very idea of painting walls and all the ideas that went to constitute the new artistic step, that went to give it life, had already existed in Mexico and had been developed and defined from 1900 to 1920, or some twenty years.[22]

Orozco joined the mural movement in 1923. Almost from the time he first experimented with fresco on the walls of the Preparatoria in murals now destroyed (figs. 10–12) he arranged giants or heavily muscled figures against a background of radiating triangular shapes, or triangles and sun-like symbols. These partly Michelangelesque, partly geometric compositions anticipate the *Prometheus*; along with them, other sections relate rather to his earlier schoolgirl paintings or to a Botticelli-like allegorical style. Jean Charlot has written that Orozco described his first panel as "Youth, Allegory of the Sun and a group of school girls." Later "Orozco went back to the center panel, destroyed it and did the giant Tzontemoc, head side down, taken from Aztec mythology (fig. 11). It is again the Sun, but this time the setting sun, ready to enter the realm of the dead."[23]

It appears that Orozco's central concern in his first mural attempts was to symbolize creative force through a combination of sun symbols and giant forms. Tzontemoc, like Prometheus, was conceived as a figure too large to stand erect on the containing wall. But in his first attempts, Orozco failed to free himself

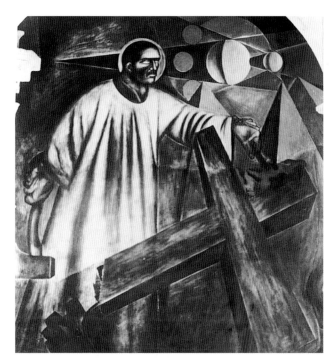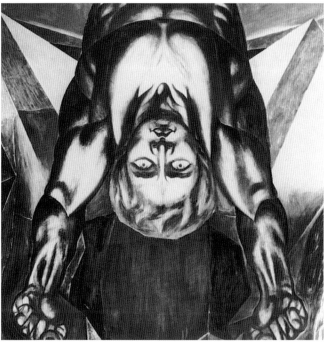

Fig. 10. (Left) Orozco: *Christ Destroying His Cross*, Preparatoria, Mexico City, 1923–24. (Destroyed except for head of Christ which appears in present fresco *The Strike*.)

Fig. 11. (Center) Orozco: *Tzontemoc,* Preparatoria, Mexico City, 1923–24. (Destroyed)

Fig. 12. (Right) Orozco: *The Two Natures of Man,* Preparatoria, Mexico City, 1923–24. (Destroyed)

from academic mannerism; he also failed to infuse the element of human experience in most of his forms and myths. In the photographs that remain, his murals seem powerful but impersonal and at times even straining for effect. Dissatisfied, Orozco replaced much of the first series in 1926.

In 1925, in the House of Tiles in Mexico City, Orozco returned to some of the first Preparatoria subjects and at the same time partly anticipated the *Prometheus*. His painting is entitled *Omniciencia* (fig. 17); it deals with creation. Hands offer the gift of fire and of matter in the upper register, while in the main composition a woman kneels between standing male and female nudes, which in turn seem to be newly formed by suggested giant figures. The creation theme, the allegory of the gift of fire or knowledge, the giants, the slightly academic approach to the anatomy—all look forward to the *Prometheus*, and also backward toward its obvious precedents in Renaissance and Greek art and thought. The figures seem about to break with the decorative clichés which detracted from his first allegorical murals, and thus they mark an advance toward the Claremont fresco. The parallels between the *Omniciencia* and the *Prometheus* go even further. In both works the central figure rests its main weight on a bent knee placed on the central axis of the composition—in both cases, this is directly over an architectural void. Behind each central figure is a somewhat similar radiating motif.

In 1926, in his last series of Preparatoria frescoes, Orozco brought to his mural figures increased emotional impact and sense of reality and life; they at times approach the form of the Titan at Pomona College. It seems that it was in the process of turning to Revolution themes that Orozco found the inspiration that enabled him to fuse the particular and general in his murals.[24] In form and subject, Orozco now began with what he felt personally and intimately: this he simplified until he achieved a statement that combined the poignancy of the

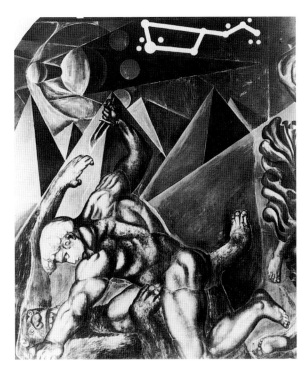

Orozco's first important mural experiments were begun at the Preparatoria about the middle of 1923; they were continued for slightly more than a year. They show stylistic and thematic anticipations of the *Prometheus*. In 1926, after Orozco began work on Revolution themes, he returned to the Preparatoria and removed all three panels (except for the head of Christ); in their place he painted *The Strike, The Trench,* and *The Destruction of the Old Order.*

immediate with the significance of the universal. In such compositions as *The Soldier's Farewell* and *The Trench* Orozco attained his second great synthesis—richer in form, broader in range, and larger in scale than that of the *House of Tears.* In developing the Revolution theme (the cycle was rounded out in easel paintings and drawings) Orozco moved toward a fuller understanding of himself, of mankind, and of art.

The Revolution in Mexico, like revolution generally, was both creative and consuming, both man's hope and despair. Contemplating it, Orozco, the creator and destroyer, penetrated to the conflict that tortured him. Salvation and damnation are paradoxically interlinked; mankind is not single but multiple and many faceted; and art, if it is to achieve the highest expression of modern consciousness, must embrace complexity and conflict. The third time Orozco attempted a mural on the theme of the source of life and knowledge, he added these essential insights. In sum, the *Omniciencia* had brought the creative myth to its climax in Mexico, and the Revolution series added concern first with conflict, then with the Masses. The *Prometheus* was to combine the *Omniciencia* and the Revolution.

Orozco consciously realized the troubled role that was the lot of the Creator-Destroyer. He had already glimpsed it in *Christ Destroying His Cross* (fig. 10), painted at the Preparatoria in 1923 (and later removed).[25] He restated it on the same walls in the *Destruction of the Old Order* of 1926. In an interview reported at Claremont in 1930 he said, in part, "Art is the creating by man of order in the universe...When an art does not properly create order; when it degenerates to a mere formula or a mere system, then it is decadent. When this comes about a new mode of synthesis is evolved as a medicine for what has come before."[26] The dose was bitter and not easy to administer in that day and place!

In the interval between the last Preparatoria murals and his arrival in Claremont, Orozco did only small paintings, watercolors, drawings and prints. On this smaller scale he advanced toward the *Prometheus* in various manners. He experimented with cubist, expressionist, and surrealist devices, undoubtedly stimulated by his contact with the pictures on view in New York at that time. He increased his calligraphic incisiveness and added new strength through distortions. (The central and left side panels at Pomona reflect some of these pictorial devices.) In subject matter, stemming from the Revolution series, came a new interest in crowds and in composition in depth.

Through Alma Reed, the artist met Mrs. Jay Hambidge, who interested him in Dynamic Symmetry. Orozco possessed a good mathematical background, and he had engaged in architectural studies as a youth; he now experimented further with picture structure, with rectangles, calculated proportions, and controlled

diagonals. He began his studies for the *Prometheus* by erecting the firmest of linear scaffoldings, with divisions based on the Golden Mean; a record of his planning remains in the preliminary drawings.[27]

Also through Alma Reed, Orozco became acquainted with the Greek colony of New York. I have already mentioned the intention of Alma Reed and Mrs. Sikelianos to stage *Prometheus Bound* at Delphi in 1929. In connection with this circle Orozco became even more intimately associated with Greek art and thought than he had been in his youth. Perhaps the best answer to the question raised by certain critics of Orozco in 1930, by what right does a Mexican depict a classic theme on Pomona's walls, can be found in the *Autobiografia* in a description of an event that took place at the home of the poet Van Noppen not long before Orozco left New York for California.

> …Dr. Kalimacos [Patriarch of the Greek Church of New York] rose and said solemnly: to us Greeks all the true artists of the world of all times are Greeks. The poet Van Noppen and I bowed and Dr. Kalimacos crowned us with crowns of laurel, giving us new names. I was rebaptized with that of Panselenos, the famous Greek painter of Byzantine times whose murals may be found in Mistra. The crown of laurel was not in this case a symbol of triumph precisely, but of adoption…
>
> It was a transparent night lit by a full moon, and on returning to Manhattan on the ferry boat, over the enchanted bay of New York, my imagination was populated by the elongated, rigid, and austere images of the apostles and virgins at the foot of a gigantic Pantocrater.[28]

It is a relatively short step from the gigantic Pantocrater to the gigantic Prometheus; here ends the search for the sources of the concept of a huge central figure surrounded by lesser men and women.

It is possible that in 1930 Orozco owed even more than this to Byzantine art. Just before he left for California, Alma Reed had held an exhibit showing the paintings of Mistra at her Delphic Studios. The Mistra frescoes characteristically show white opaque brushwork that stands out against more thinly painted passages. In his smaller paintings of the New York period, Orozco had already explored the expressive possibilities of opaque brushwork in oils and gouaches. Throughout the *Prometheus*, chalky whites appear with dramatic effect. Their use was to be carried even further in his later murals.

Another expressive means that Orozco had explored in the New York easel paintings contributed to the strength of the Claremont fresco. Before 1927 Orozco had apparently never worked extensively in a medium and manner that encouraged him to experiment broadly with heightened colors. In his *Autobiografia* he remarks that in 1913, when Ramos Martínez sought to introduce the Impressionist palette at the Academy, his own preference was for black and the earths. The *House of Tears* watercolors are on the whole subdued in color, and the Preparatoria murals generally favor the earths and muted tones, though sometimes incorporating strong blues or rising in intensity to a powerful warm glow. In its first impact the *Prometheus,* with its mass of flaming reds penetrating

the figures, announces the arrival of a color expression heightened beyond that of even *The Trinity* and *The Trench*. Although the painting seems at first glance somewhat limited in color range, the total composition is carefully planned in terms of areas which introduce a variety of hues, especially on the side walls. Intense blues and reds and warm earths dominate, but there are striking passages of black-and-white, chalky pink, yellow and yellow-green, violet earth, orange, and vivid cold blue-green. The *Prometheus* reveals that by 1930 Orozco had entered on the road that was to lead to the chromatic brilliance of the walls at Dartmouth.

Yet one other development since the last Preparatoria murals appears in Claremont, a concept whose growth may be traced in Orozco's Revolution and New York pictures. The smaller figures show for the first time in Orozco's painting the developed theme of the Masses (figs. 2–3). They play here a new role: they serve as a foil that gives meaning to their opposite, the Hero. Orozco was anxious that his crowd-symbol be viewed all together, not taken apart.

> The crowd is just as you see anywhere. The crowds are always in motion—I have tried to make them dynamic. They move; they do things. Look at any crowd; it is made up of many people.…All of them are active.[29]

The artist succeeded in suggesting both extreme diversity and cohesive massing. He created a profound symbol for mankind itself.

Other artists, like Daumier, had represented the modern masses. The subject was not new, though Orozco's expression was his own. The concept was taking on new meaning in relation to the modern world. The 1929 Crash had already placed social relations in a new perspective. In 1930 Ortega y Gasset's *La Rebelión de las masas* appeared in book form, and in September of the same year, Hitler's National Socialist Party rose to ascendancy, partly as a result of the Depression. The universality of the *Prometheus* is such that its implications are both timely and timeless.

* * *

The above observations show us the variety of ways in which the *Prometheus* summarizes Orozco's earlier work in technical means, color, form, concept, and expression. These also have included references to Orozco's transition and innovation in 1930.

The transitional nature of this work will especially strike the observer if he compares his impressions of the total view with the details, or of the Titan and the crowd. One's first impression upon entering the hall is of the great Michelangelesque central figure. As the spectator approaches, the wall surfaces assert themselves and take on more abstractly expressive qualities, particularly in parts of the crowds. Although the painting brings Orozco's Preparatoria manner to a culmination, it also prepares us for his future work in which specific dependence on the academic approach to form and subject will drop away. In combining traditional and new approaches, the *Prometheus* betrays a certain inconsistency, but this does not overbalance the powerful unifying elements, compositional and expressive. It retains the forthright emotional impact of a great work of art.

In 1930 Orozco was at the point of intensifying his formal means; the quality of "direct expression" was developing rapidly. At the same time, he had learned how to present his concept of humanity and his "totemic" concept: the Creator-Destroyer, the Fire-Titan. Prometheus represents Orozco. He also represents the creative spirit of man himself: Man as he reveals his divine aspect, tortured and consumed by both his human weakness and the essence of his greatness. Man in his glory and his tragedy—a poignant conception, yet affirmative; terrible, yet heroic. Man in his isolation, surrounded by the sea of Mankind.

The great course that Orozco entered upon here did not proceed directly and smoothly to its logical culmination in a work combining similar universality with complete stylistic freedom. His next murals, in the eastern United States, were more programmatic. In the New School for Social Research in New York he explored Dynamic Symmetry further, and at Dartmouth he tried—not without success—an epic narrative composition that recalls Claremont only in parts.

Orozco's mural series in Guadalajara (begun in 1936) provide the most notable continuation of the *Prometheus*. At the University, the Government Palace, and especially at the Orphanage, whose dome bursts into flame with man becoming fire, we find confirmation of the thesis that the *Prometheus* is but one statement—though a very important one—of Orozco's central theme.

As Orozco the myth-maker became able to create his own symbols directly, with an immediacy of expression which freed him from dependence on ready-made signs and on direct allusions to the Greeks, the Indians, or the Mexican Revolution, he painted new worlds peopled by new men, driven by the unseen forces of life. In the fresco at Pomona College he showed, for the first time in his murals, his fiery Hero and his new Mankind in the aggregate. The *Prometheus* stands as a masterful introduction to what was to become the most astonishing cycle of cosmic myths created by a modern artist.

1. José Clemente Orozco, "New World Races, New Art," *Creative Art,* vol. IV, no. 1 (Jan. 1929), p. xiv.

2. The *Prometheus* was begun in April, 1930. Joseph Pijoán, the Spanish art historian (then on the faculty of Pomona College), was the initiator of the project. Jorge Juan Crespo de la Serna, at that time an instructor in a Los Angeles art school and now a prominent Mexican critic, helped arrange for the mural and assisted Orozco in the actual painting.

3. The first-prize sketch, by Erwin Hetsch of Germany, began its symbolization of the exhibit theme, "The Dynamic of Man's Creative Power," with a figure of Prometheus.

4. Although it would seem, for many reasons, most natural for Orozco to have thought of the Prometheus theme, it appears that the subject was first suggested by Joseph Pijoán.

5. Interview with Orozco, Pomona College *Student Life,* May 17, 1930.

6. Luis Cardoza y Aragón, *Pintura Mexicana Contemporánea,* Mexico, D.F., 1953, p. 308. (The passage appeared earlier in the same author's *José Clemente Orozco,* Buenos Aires, 1944.) See also the significant reaffirmation of this observation by Jorge Juan Crespo de la Serna, "Sentido y Gestación del Prometeo de Orozco," *José Clemente Orozco, Homenaje,* Mexico, D.F., 1952, p. 15.

7. *Arts,* Oct. 1927, p. 209.

8. *El Nacional,* Sept. 20, 1916, p. 3. Reprinted in Justino Fernández (ed.), *Textos de Orozco,* Mexico, D.F., 1955.

9. The next section of the paper is concerned with tracing influences on Orozco which have a relation to the *Prometheus,* but I omit mention of some which have been adequately dealt with elsewhere.

See, for example, on El Greco, the remarks of Laurence Schmeckebier in *Modern Mexican Art* (Minneapolis, 1939), pp. 447–75 and 88. Likewise, I do not mention in this connection Tintoretto, Goya, Daumier, Toulouse-Lautrec, Ensor, Grosz, Picasso, Posada, or the other Mexican muralists of the twenties; these have been treated by Tablada, Cardoza y Aragón, Fernández, Crespo de la Serna, and other critics.

10. José Clemente Orozco, *Autobiografía,* Mexico, D.F., 1945, p. 12. (The translations throughout this article are my own.) The *Prometheus* is a splendid example of the architectural strength of Orozco's mural designs. Sumner Spaulding, architect of the building, was reported as having remarked, "I feel as though the building would fall down if the fresco were removed." (*Time,* Oct. 13, 1930, p. 30.)

11. *El Mundo Ilustrado*, Mexico, D.F., Año XIV, no. 1 (Jan. 1, 1907), n.p.

12. J. C. Orozco, *op. cit.,* p. 20. Orozco's reference to the Sistine recalls the numerous reflections of Michelangelo in the works of the modern painter. The Christ of the *Last Judgement* and certain other figures invite comparison with *Prometheus,* a subject well introduced by Justino Fernández in his *José Clemente Orozco, Forma e Idea* (Mexico, D.F., 1942). It is not by accident that Michelangelesque forms occur in Orozco's murals: in a now destroyed panel of the Preparatoria series *(Two Natures of Man,* 1923) the head of the idealized figure appears to be taken directly from such a prototype as the *David* (fig. 12).

13. Orozco is not mentioned in the magazine, nor does he himself mention it in his *Autobiografía.* That he knew it and that it reflected his environment is beyond doubt. Associated with the *Revista,* or represented in it, were José Juan Tablada (whose articles Orozco illustrated in *El Mundo Ilustrado* in 1907 and who became Orozco's first champion in 1913); Julio Ruelas, whose work Orozco admired; don Jesús Luján, to whom Orozco made his first sale (of a cartoon) in 1910; several Academy teachers whom Orozco especially recalled—Fabrés, Izaguirre, and Gedovius; and friends or near-contemporaries of Orozco such as Dr. Atl, Ramos Martínez, Saturnino Herrán, Alberto Fuster, Jorge Enciso, Diego Rivera, and the brothers Garduño.

14. J. C. Orozco, *op. cit.,* p. 19.

15. José Juan Tablada, "Un pintor de la mujer, José Clemente Orozco," *El Mundo Ilustrado,* Nov. 9, 1913.

16. *Nuevo Mundo,* Madrid; reprinted in the *Revista Moderna,* Feb., 1909, p. 374.

17. *Revista Moderna,* vol. VII, no. 3 (Nov., 1906), p. 163. J. J. Tablada had earlier described it in the *Revista,* vol. I, no. 2 (August 15, 1898), p. 19.

18. *Ibid.,* May, 1907, p. 158.

19. Orozco is reported to have explained his Normal School mural as follows: "Black…stands for hopelessness and death; red squares and streaks for strife; blue for triumph, white stands for purity." *Life,* Nov. 22, 1948, p. 69.

20. Alberto Garduño was one of several artists who depicted Prometheus about this time. See his illustration in *El Mundo Ilustrado* for 18 June 1911.

21. Justino Fernández goes even further in his *Prometeo* (Mexico, D.F., 1945), p. 155, and *Arte Moderno y Contemporáneo de Mexico* (Mexico, D.F., 1952), p. 352. The sum of his argument is that European painting reached its climax in modern synthesis with Picasso's *Guernica* in 1937, whereas Orozco had arrived at a comparable point in 1913.

22. J. C. Orozco, *op. cit.,* p. 79.

23. Jean Charlot, letter to the author, undated (1955).

24. My conclusions concerning the dating of Orozco's work have been arrived at independently. I am gratified to find them confirmed by Jean Charlot. See "Orozco's Stylistic Evolution," *College Art Journal*, vol. IX, no. 2, pp. 148ff.

25. All but the head of Christ was removed; this was left curiously inserted over the doorway of *The Strike* (1926). The symbolism of the head and the reason for its retention become more understandable in view of this discussion.

26. Pomona College *Student Life*, May 26, 1930.

27. *See Exposición Nacional José Clemente Orozco,* an illustrated catalogue published by the Secretaría de Educación Pública, Mexico, 1947.

28. J. C. Orozco, *op. cit.,* p. 130.

29. Interview, *The Student Life,* May 17, 1930.

Prometheus Revisited

by DAVID W. SCOTT

In 1963, six years after writing the preceding article, David W. Scott became director of the Smithsonian Institution's National Collection of Fine Arts; in 1969, he joined the staff of the National Gallery of Art as planning officer for the Gallery's East Building. It was only in the 1980s that he was able to return to Orozco. "Prometheus Revisited," first written for a lecture in 1984, was revised for this publication.

OVER THE YEARS I have written and lectured several times on the subject of Orozco's *Prometheus* and its innovative significance. My initial views of the fresco—or frescoes— in Frary Hall, described in 1957, have evolved into an expanded thesis: the *Prometheus* represents Orozco's first fully realized mural cycle and the first unfolding of the artist's philosophic view of the human condition that is the basis of all three murals in the United States, foreshadowing the great works in Guadalajara to follow. The compressed but explicit Pomona cycle reveals, on analysis, Orozco's first extended program for expressing the general philosophy that underlies his titular subjects and shapes their episodes. As his first unified cycle, it is also the earliest reflection of what became his program for selecting the specifics of form and content in his subsequent murals.

I shall consider, first, the Frary frescoes, then some earlier Mexican works for comparison, and finally the cycles at the New School for Social Research (now New School University) in New York City and Dartmouth College in Hanover, New Hampshire. I refer to the Frary "frescoes"—using the plural for perhaps the first time—because we have not one painting but four. It was the more or less accidental presence of the surrounding vault and side panels that gave Orozco—probably as an afterthought—the opportunity to expand his theme, an approach later echoed in New York and Hanover. There are (1) the source of inspiration (at Frary, the abstract godhead symbol); (2) the heroic figure drawing the fire (enlightenment) from it; (3) both the reception and rejection of the hero's offering of his gift of enlightenment by the masses; (4) the destruction of the old order, symbolized by the consternation of Zeus and Hera in the left panel, and the overthrow of the centaurs (ancient superstitions) to the right; and, finally, (5) signs of hope for mankind in those few who welcome the fire and in the very presence of a godhead, however remote (figs. 13–16).

Fig. 12a. José Clemente Orozco, *Prometheus*, 1930, central panel (detail), Pomona College, Claremont, California.

27

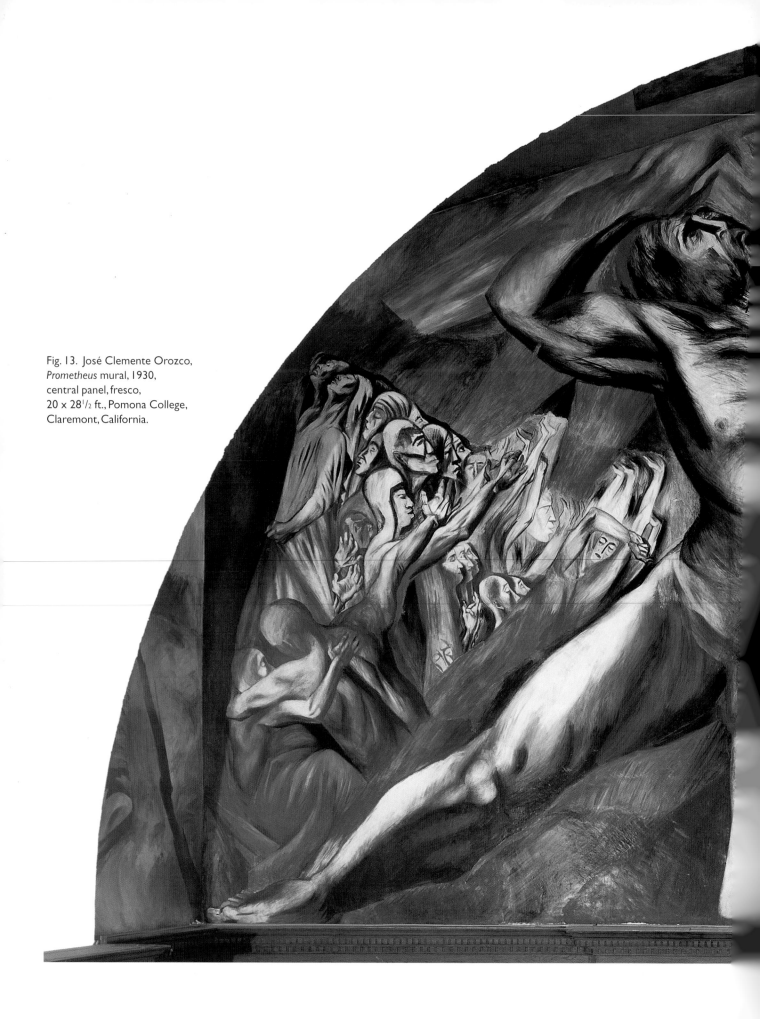

Fig. 13. José Clemente Orozco,
Prometheus mural, 1930,
central panel, fresco,
20 x 28$\frac{1}{2}$ ft., Pomona College,
Claremont, California.

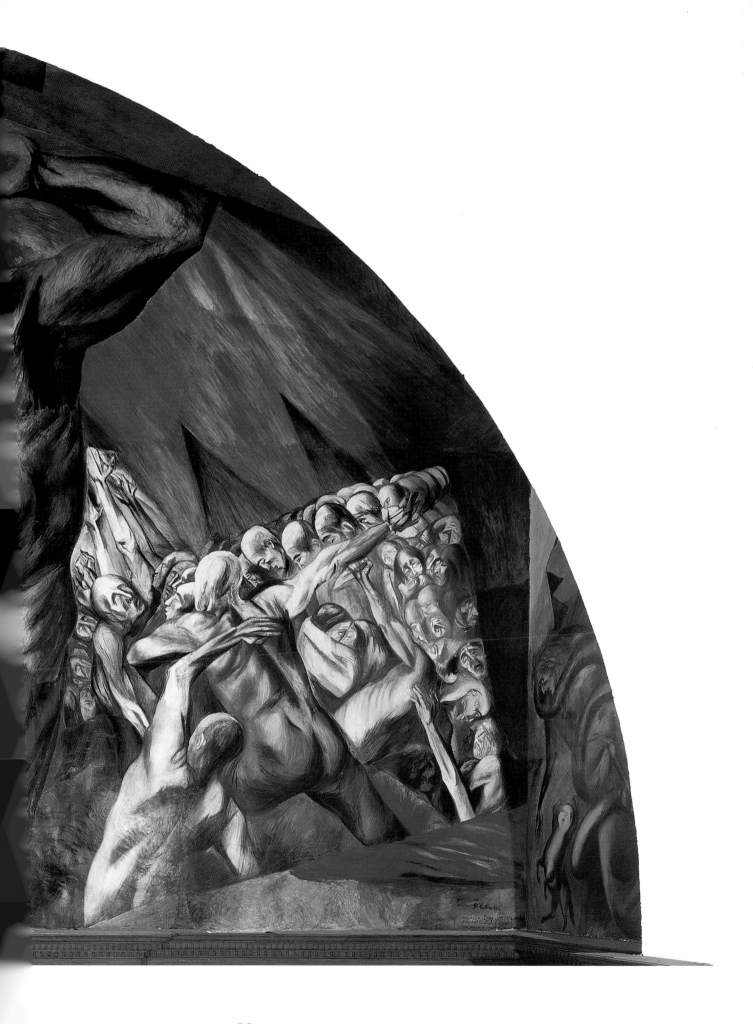

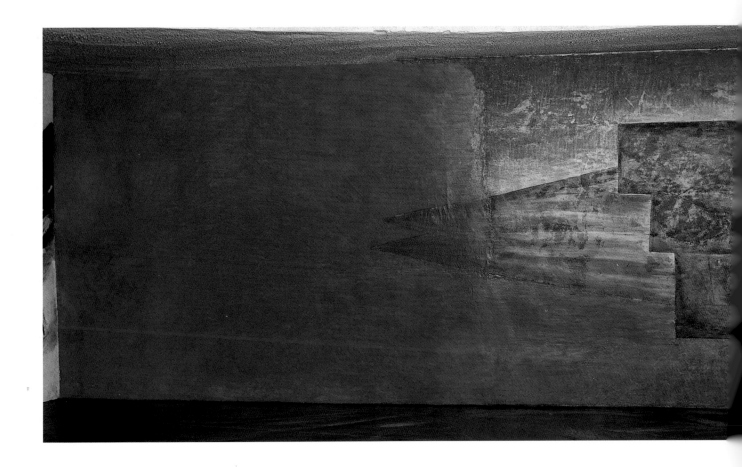

Fig. 14. José Clemente Orozco, *Abstract Composition* or *Godhead*, *Prometheus* mural, ceiling panel, 1930, fresco, 7 x 28¹/₂ ft., Pomona College, Claremont, California.

It may seem curious that of the five parts of the philosophic program, three are more or less hidden on the surrounding panels. Their themes do indeed seem to have come in response to the spaces available and been developed as an afterthought. A case in point: Orozco first painted the head of Zeus in the vault: after all, it was from him that Prometheus stole the fire. But Zeus represented the "old order" that was to be destroyed. Hence, upon further thought, Orozco replaced him with a symbol of the ultimate source of man's inspiration (and salvation), an enigmatic, radiating geometric abstraction (fig. 14). If Orozco was groping toward the full expression of his philosophic concept, the parts are all to be found nevertheless in his final cycle. The fact that the program is still in embryo here makes the mural all the more significant.

My five-point summary of Orozco's philosophic program, in itself, might give the impression that the artist's cycles were pleasantly optimistic—that a hopeful outcome casts a cheerful light on the whole. Quite the contrary: they contain, to borrow a quotation from the master himself, "a little yes and a big no!" But the glimpse of a small, possible "yes" at the end of a long, painful struggle unites the three American cycles.

The *Prometheus* cycle also reveals the beginning of Orozco's program in developing specific references to the site and even the time of his mural series. First, he relates this work to the institutional setting, in this case Pomona College, which by its very name makes a classical reference, and which, as an institution, is devoted to the bringing of enlightenment. Thus the aptness of the Greek

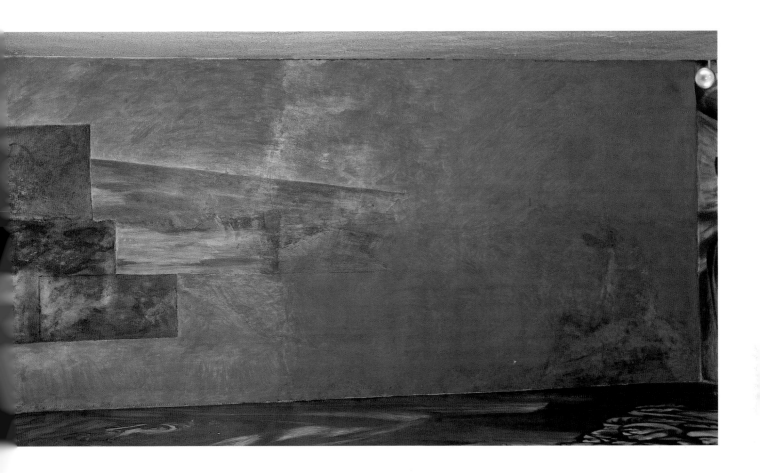

Titan Prometheus, who also reminds us that true enlightenment is a precious gift that may come painfully. The crowd could be the students: the favored few accept, more are indifferent, and many reject their opportunity. What more appropriate symbol? (Admittedly, Orozco was ignoring the inappropriateness of a gigantic suffering male nude as a refectory decoration, but the artist was doing more than decorating.) Second, Orozco's schema relates to, even enhances, the architectural setting: a vigorously scaled main subject on principal axis, with symmetrical lateral developments. Sumner Spaulding, the architect of Frary Hall, said he felt as though the building would fall down if the fresco were removed. And, finally, the artist included a leitmotif of the times: a footnote on the artist's life appears at the bottom of the right-hand panel, the touching baby centaur reminding us of the artist's separation from his infant children whom he had left in Mexico three years before (fig. 16).

Since it is my thesis that the *Prometheus* initiates in Orozco's art these cycle programs, both philosophic and site-specific, I must consider, at least briefly, his earlier Mexican murals. In fragmentary fashion, these bring him to the verge of the *Prometheus*, but he had not had the opportunity, before completing his last Mexican fresco in 1926, to bring his mature talents together in one large, unified project. In his first Preparatoria murals, begun in 1923, Orozco had dealt with cosmic themes in giant, Renaissance-derived figures, but the results were strangely cold and derivative. He had painted, and later removed, the subject of Christ Destroying His Cross (fig. 10) (that is, rejecting the corruption of his

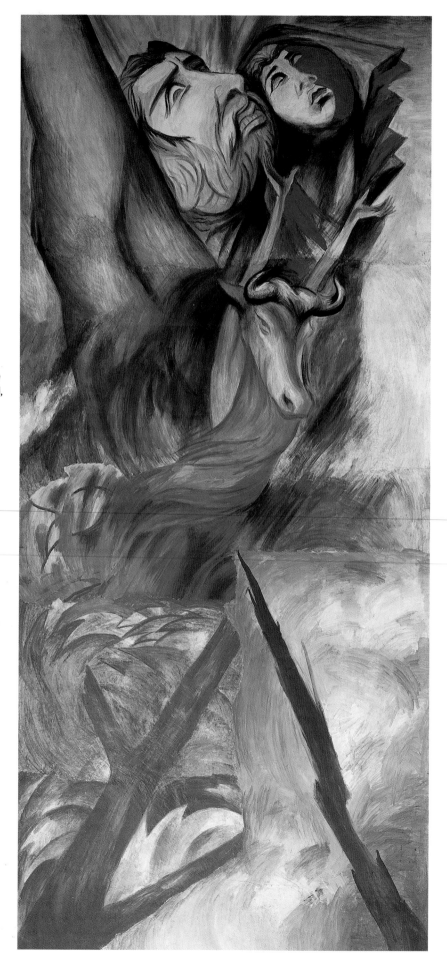

Fig. 15. José Clemente
Orozco (and Jorge Juan
Crespo de la Serna?), *Zeus,
Hera, and Io* or *The Destruction
of Mythology*, *Prometheus* mural,
west panel, 1930, fresco,
15$^1/_3$ x 7 ft., Pomona College,
Claremont, California.

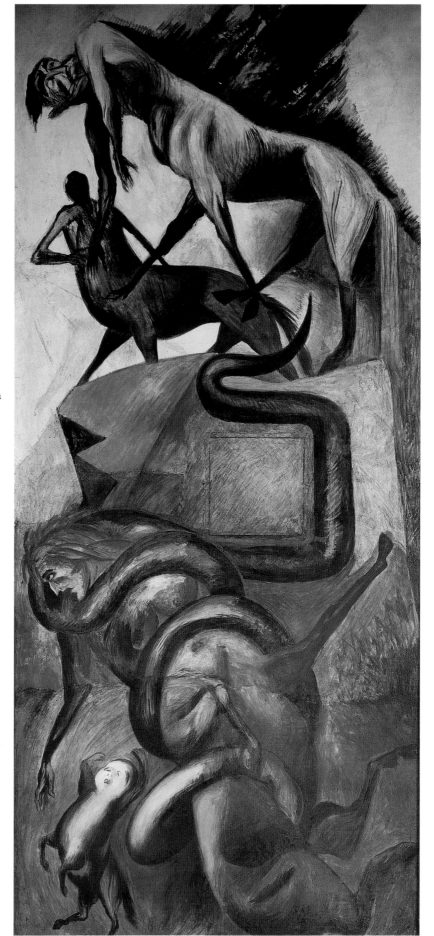

Fig. 16. José Clemente Orozco
(and Jorge Juan Crespo de la
Serna?), *Centaurs in Agony* or
Strangulation of Mythology,
Prometheus mural, east panel,
1930, fresco, 15¹/₃ x 7 ft. , Pomona
College, Claremont, California.

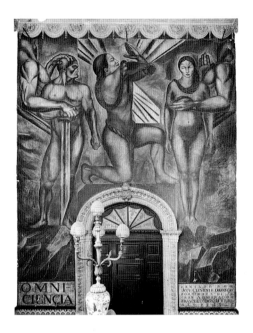

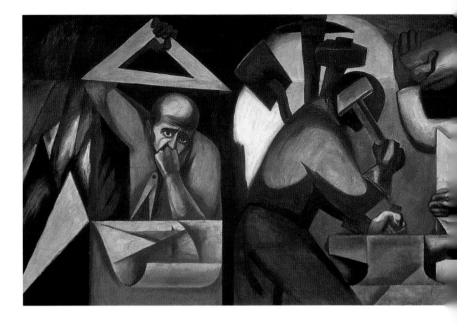

Fig. 17. José Clemente Orozco, *Omniciencia,* 1925, fresco, House of Tiles (Sanborn's Restaurant) Mexico City.

Fig 18. José Clemente Orozco, *Revolution and Universal Brotherhood: Science, Work and Art,* 1931, fresco, New School University, New York, New York.

institution), later used so effectively at Dartmouth. Orozco had arrived at a sober, moving, and personal style in his 1926 mural panels of Mexican soldiers. However, none of these prepares us for the fiery color and expressionism of the *Prometheus,* the new concept of the human figure among the masses, or the philosophic breadth of theme. Orozco's development as an artist during his three years in New York City, evident in his graphics and small canvases, forms a bridge between 1926 Mexico and 1930 Claremont, but during that period he had no chance to paint a mural, and his pent-up frustration helps explain the violence of his outburst at Frary.

The one large philosophical fresco Orozco did in Mexico City, the *Omniciencia* at Sanborn's painted in 1925 (fig. 17), demonstrates how great a gulf he actually bridged in the next five years. Because its central figure reminds us of the *Prometheus* by similarities of theme, format, and scale, the contrast in effect is all the more striking. The great nude figure, with weight on one knee over a central architectural void, looks upward—arms raised—to receive inspiration, and rays extend from her. In contrast, figures representing Force, and Intelligence—for the artist, subordinate attributes—are restrained by giant arms on either side. *Prometheus* is foreshadowed, but without passion. I hope that at this point it is obvious that the *Prometheus* cycle, for all its links to earlier frescoes, was very much a new departure for Orozco. What I believe is new to this discussion is the relating of the innovations in the Claremont work to the very different-looking cycles in the painter's two subsequent American frescoes.

The first of these cycles, *Revolution and Universal Brotherhood* at the New School, is somewhat of an anomaly in Orozco's work. It was painted under unusual circumstances and is unusually doctrinaire and formal. As a result, it presents a bit of a challenge and an interesting test of my thesis. While Orozco was still in the midst of painting the Pomona College fresco, his New York dealer the colorful Alma Reed, was already negotiating for the next mural. As she recounts

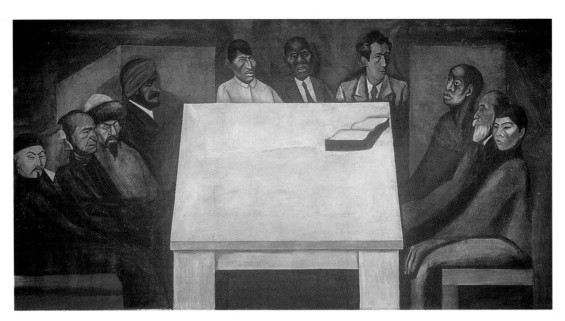

the story, she came across Joseph Urban's plans for the New School building at an Architectural League exhibition. Struck by the possibility of a mural project, she went first to see Urban and then to the director of the New School, Dr. Alvin Johnson. Everything proceeded smoothly and an agreement was reached. Johnson approved Orozco and asked only that the subject be contemporary and of lasting significance. There was no question of fee: the mural was to be donated by Alma Reed and the artist. The opportunity to execute a major New York fresco in a semi-public building under the public eye justified the donation. The timing seemed right: the painting was to be done a few months following the work at Claremont, just as the New School building was being finished and readied for opening. Architecturally, the building promised to be distinguished, and the school's philosophy was congenial. Indeed, it must have seemed the ideal setting for a depiction of the social and pacifist—and even personal—concerns of Alma Reed's Ashram salon itself.

Alma Reed, Orozco's fervent supporter, patron, and dealer, attracted a diverse group of activists to her Ashram meetings (named after Mahatma Gandhi's retreat). Orozco knew them well. One, the Indian poetess Sarojini Naidu, was a Gandhi disciple. Alma herself, long an advocate of Mexican causes, had been engaged to the reform governor of Yucatán, the progressive idealist Felipe Carrillo Puerto, before his assassination. Another member, the widow of the founder of Dynamic Symmetry, Jay Hambidge, had long sought to engage Orozco in carrying on with her husband's geometric design system. Orozco was to make his New York mural debut under the watchful eyes not only of the architect, the director, and the art critics but of these very partisan ladies as well.

Orozco returned from California in the late summer of 1930. He worked on sketches for his murals, and by November was ready to start painting. Things went slowly at first, and it turned out that he was working under more pressure than at Pomona, where there had been no deadline. He was also working under

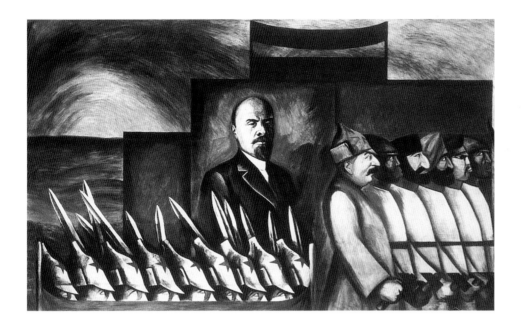

Fig. 20. José Clemente Orozco, *Revolution and Universal Brotherhood: Carrillo Puerto and Lenin*, 1931, fresco, New School University, New York, New York.

other difficulties: he was portraying a far more complex set of themes in a cramped space. The ceiling was low and the walls broken by windows and doors. Even the actual application of paint seems to have caused trouble. In spite of all this, he finished the four walls and the entry panel in time for the January 19, 1931, dedication.

The visitor to the seventh or top floor of the New School building approaches the former dining hall, now turned classroom, through a large hall that presents an introductory panel announcing the mural cycle beyond. The panel's subject, *Science, Work and Art* (fig. 18) (called by the artist *Allegory of the Sciences and the Arts*) may seem to have little to do with the main cycle on the theme of Revolution and Brotherhood, but it addresses Orozco's recurrent introductory theme: here a scientist and an artist, absorbed in their projects, reach above for knowledge and inspiration. A worker, between them, implements their plans. The scientist, his face contorted in thought, reaches for form (the triangle) that he reduces to measure (the compass). The artist—the favored figure in Orozco's depiction—reaches for the rainbow (inspiration) and reduces it to form (the triangle again). The analogy with the *Prometheus* is clear. Though no godhead is shown, a heavenly source of a divine gift is indicated.

In the main room, Orozco's philosophic program continues, but with some discontinuity. The central panel opposite the entrance shows *The Table of Brotherhood* (fig. 19); the side walls depict revolution, reform, and suffering; the fourth wall shows the home table of the worker's family. The universal brotherhood panel, with its striking white square of a table surrounded by men rather stiffly arranged to represent different races, is politically correct for its day but emotionally cold. (To be "correct" today, of course, it would include women, which might relieve it.) The panel functions most strongly as establishing a powerful focal point and axis. The corresponding and opposite panel, centered again on a table, picks up the axis but with different effect.

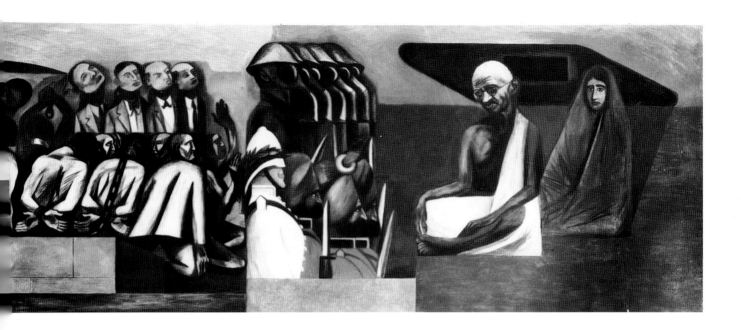

Fig. 21. José Clemente Orozco, *Revolution and Universal Brotherhood: Gandhi, Imperialism and Slavery*, 1931, fresco, New School University, New York, New York.

The two long side wall panels have been titled *Carrillo Puerto and Lenin* (or *The Occident*) and *Gandhi, Imperialism and Slavery* (or *The Orient*). Along with masses of people (soldiers, peasants, slaves), three large portraits stand out—the heroes of this cycle. Each of the side walls is again divided into two subjects. For *The Occident* (fig. 20), these are Mexico and Russia. The Mexican panel begins with a somewhat idealized bust portrait of the martyred Carrillo Puerto beside the pyramid of Chichén-Itzá. Below is a huddled mass of Indian women and children, mostly impassive, but dominated by three who look toward the hero. A guard with a rifle adds a dark note to the scene.

The Occident continues with a large bust of Lenin above faceless marching soldiers. Ending the panel is a row of six larger figures with workers' tools, beginning with a portrait of Stalin and depicting Russian racial types. It is interesting to note that Lenin's head is clearly at a lower level than Carrillo Puerto's; nevertheless, the inclusion of both Lenin and Stalin is most unusual in Orozco's art. The artist held profound reservations about Communism. Given the theme of revolution, it would have been hard to ignore Russia, but it may be significant that in this panel there is no reference to the plight of the common people—only an acknowledgment of racial equality.

On *The Orient* wall Orozco dramatizes human misery (fig. 21), echoing the masses at Frary. Gandhi sits, full figure, accompanied by a female disciple, Sarojini Naidu, whom Orozco knew through meetings at the Ashram. Opposite and behind him are symbols of military might, and beyond, slaves in chains, some bowed, some rebellious, all victims of the corrupt order that must be overthrown. Behind and above the slaves are figures of the bourgeoisie, themselves caught by the neck and also victims of the system. In 1930, the year of Gandhi's defiant march to the sea, the impact of the scene would have been vivid.

So far, in our survey of the New School cycle, we have seen (1) inspiration drawn from above; (2) representations of the hero, including the suffering hero;

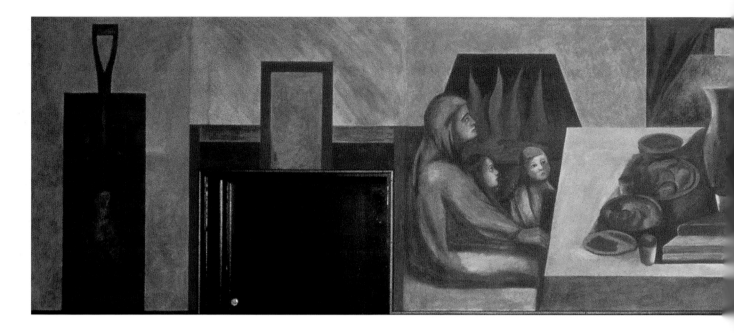

Fig. 22. José Clemente Orozco, *Revolution and Universal Brotherhood: Return of the Worker*, 1931, fresco, New School University, New York, New York.

(3) the masses, if only in small groups, relating to the hero; and (4) allusions to the corrupt old order, although no actual scenes of its destruction. The fifth phase, the hopeful light, might have been implied by *The Table of Brotherhood*, but that light is a very cool one, and I see the panel not as an end but as a means to the end. The warm light comes from the fourth wall, the *Return of the Worker*, also called *The Table of Home and Hearth* (fig. 22). There, two women, at either side of a table laden—significantly—with food and books, welcome workers home from their labors. It is a scene with a cheerful hearth and three children, one of whom embraces her father. A factory appears in the distance, through a window, symbolically echoing the square of the table.

In summary, in the New School cycle, inspiration and heroic leaders are necessary. In a just social order, which may well require a revolution—pacific (Gandhi) or bloody (Russia)—there will be not only equality (at the one table) but love, comfort, and joy for all classes (at the other). And finally, there is a glimpse of hope for mankind.

Beyond his philosphical program, Orozco developed specific references to the site. First, he did indeed respond to the institution, meeting the Director's request for the depiction of current events of long-term significance. The New School was an educational institution studying current social problems. Second, in its space, architecturally and axially, the cycle was most carefully ordered and balanced. Orozco in this case carried to an extreme his design development in terms of the rectangles and diagonals of dynamic symmetry, which related to the modernist idiom of Urban but restrained the artist's expressive genius. Again, and more specifically, the site was a school restaurant; on one axial table was a book, and across the room, past the functional restaurant tables, was a painted table with food and books. Finally, I see Orozco's own three children here, now near school age, adding an intimate reference and immediacy to the symbolism of the panel. Although Orozco's mural-cycle conceptual program underlay, and

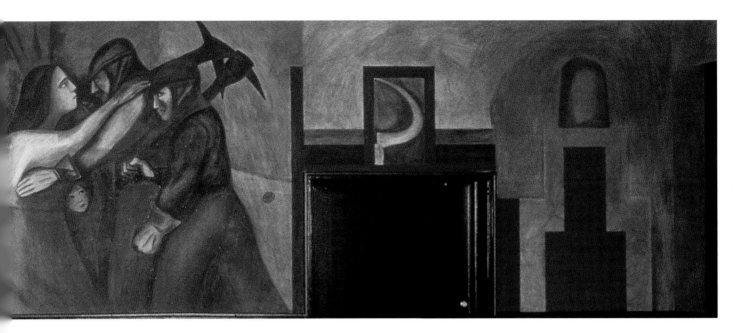

may be deciphered in the New School murals, this cycle was not one of his most successful, due to several constraints that affected his presentation of themes. In the end, its reception was lukewarm. He was shortly to find, at Dartmouth College, a very different site and opportunity.

At Dartmouth, in contrast to Pomona College, Orozco had a college president and art department that not only welcomed him but also sought him out. He had a patron, in the Rockefellers, ready to offer him an art professor's salary while he painted. He had complete freedom to choose his themes, and—unlike Pomona and the New School—ample space to develop them. Given these circumstances, we have an ideal opportunity to test my thesis of the artist's general philosophic and site-specific programs.

Orozco was first invited to Dartmouth in May of 1932 to paint a relatively small panel above the door of a corridor leading into the basement room of the Baker Library. His commission was in the nature of a teaching assignment for the art department, demonstrating the fresco technique, and the resulting panel may be said to illustrate rather than express its subject. A male figure, rising above a trash-heap of symbols of our material culture, raises his hands, seeking help from above. It has been called *Man Released from the Mechanistic to the Creative Life*. The theme is characteristic of Orozco, recalling both the *Prometheus* and the *Artist* at the New School, but unlike in those works, there is no struggle, and unlike the Library series to follow, no bitterness.

While preparing to paint *Liberation*, Orozco discovered the great walls of the library's Reserve Book Room, 24 feet wide by 150 feet long—"the wall of my dreams"—large enough for him to portray his dreamed-of epic of America. He began to sketch ideas for the realization of his epic on those walls and spent the next two years carrying out his project. His concepts grew and evolved as he went along. The completed cycle, titled *The Epic of American Civilization*, together with the changes that lie back of it, offer us the best possible test case for

Fig. 23. José Clemente Orozco, *The Epic of American Civilization (West Wing view)*, 1932-34, fresco. Commissioned by the Trustees of Dartmouth College, Hanover, New Hampshire.

Fig. 24. José Clemente Orozco, *The Epic of American Civilization (East Wing view)*, 1932-34, fresco. Commissioned by the Trustees of Dartmouth College, Hanover, New Hampshire.

the application of my thesis. As Orozco progressed from panel to panel, he brought the episodes more closely in line with his general philosophic overview and also with his formal and axial design program. At the same time, his message grew progressively more pessimistic.

The walls of the western half of the long room depict the ancient or Indian part of the epic (fig. 23); the eastern half depicts the modern world, from the arrival of Cortés (fig. 24). Between the sections, at the center of the long northern wall, is the reserve desk. The epic begins at the western end wall, depicting the ancient Indian world before the arrival of Quetzalcoatl. The arrival and departure of Quetzalcoatl occupy the principal panels on the long wall leading to the reserve desk. *Cortés and the Cross* introduces the modern-world panels, concerned largely with a bitter condemnation of modern mechanistic and material culture, culminating on the eastern end wall with the violent and arresting image of *Christ Destroying His Cross*. The long south wall is largely punctuated by windows, but at the center, opposite the reserve desk, is the panel *Ideal Modern Culture II*, showing modern industrial man.

In reviewing the episodic units in more detail, the site-specific (and time-specific) program becomes evident. Panel groups, and even several individual panels, present corresponding themes in strict symmetry, responding to the axes of the room. The college mission is reflected not only in the Enlightenment theme but also in Dartmouth's founding purpose of serving the Native Americans, "the Ancient Order." The library setting is echoed in book references. Finally, we are reminded again of Orozco's children, now of school age, when we encounter a school and schoolhouse scene.

The Epic of American Civilization cycle begins with the introductory panels on the west end wall. These may be taken as showing, first, the "masses" of the ancient Indian worlds as man with potential for strength and weakness, good and evil. The evil is then made explicit in *Ancient Human Sacrifice*, an example of a cor-

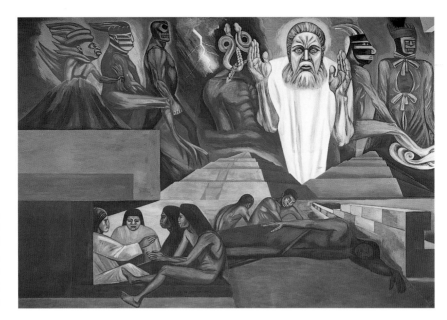

Fig. 25. José Clemente Orozco, *The Epic of American Civilization: The Coming of Quetzalcoatl* (Panel 5), 1932-34, fresco. Commissioned by the Trustees of Dartmouth College, Hanover, New Hampshire.

rupt old order. The theme of hope for man, coming in the form of an inspired hero, is introduced on the main wall with *The Coming of Quetzalcoatl* (fig. 25), the "feathered serpent" man-god of Indian legend who, like Prometheus, brought the arts to man. His visage, hypnotic and otherworldly, is suffused with light coming from above. He breaks out in front of figures of superstition and introduces the arts and sciences to man—symbolized by the pyramids, the agricultural worker, and the sculptor. But the forces of superstition rise against him, and he departs on a raft of serpents, pointing to the future, prophesying his return. The elements in the episode are similar to those in the *Prometheus* cycle, but varied and expanded.

The Quetzalcoatl episode ends at the center of the wall, where the reserve desk creates a caesura. Orozco bridges the gap, and stresses the central axis in design and theme, by dramatic devices: the vigorous horizontal of Quetzalcoatl's arm thrusts toward the panel at the other side of the reserve desk, where the strong verticals of the Cross and the figure of Cortés pick up the dramatic fulfillment of Quetzalcoatl's prophecy.

The eastern section of the long wall presents five themes in a continuous painting. Unlike the western section, there is no historical sequence, except that the arrival of Cortés introduces the modern world. There are three dominating figures, functioning in the design as heroes have in earlier paintings, though the first, Cortés, is a symbol of change and the overthrow of a corrupt order, not of a bringer of light. The treatment of Cortés is interesting in view of his negative characterizations in Orozco's later work: here he seems to be too handsome and majestic to personify the evil that followed him, and I believe he is portrayed rather as a force of destiny. The evil that followed (*The Modern Machine Age* of the next episode, and in the concluding episodes) is the fault of man's cupidity, not of Cortés.

The panel is well described in the descriptive pamphlet put out by Dartmouth upon the completion of the cycle in 1934: "In this panel the con-

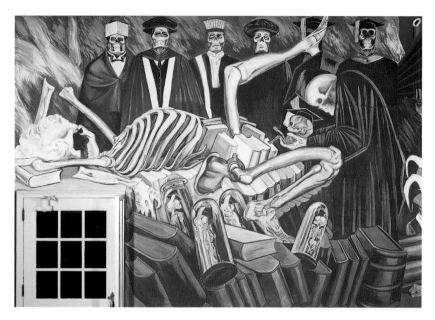

Fig. 26. José Clemente Orozco, *The Epic of American Civilization: Gods of the Modern World* (Panel 17), 1932-34, fresco. Commissioned by the Trustees of Dartmouth College, Hanover, New Hampshire.

quering figure of Cortés appears against the background of his burning ships, destroyed by himself, and of the stern cross both supporting and supported by an ascetic priest. Underfoot are ghastly heaps of slain and subjugated natives and the wreckage of a despoiled civilization. In the figures of both Cortés and the priest are represented the mixture of positive and negative values inherent in the conquering European culture."

The following panel, *The Modern Machine Age*, may be seen as depicting glowing, somewhat idealized machines in the background, more agitated and confused ones in the middle distance, and chaotic ruins in the foreground. It is a world of inhuman giants, apparently consuming human bodies in its maw.

The following two panels form a pair, *Anglo-American Society* and *Hispano-American Society*. The hero-figures are a grim American schoolteacher and an equally determined armed Mexican peasant, reminiscent of Zapata. In the American scene, we see in a town meeting and a school group Orozco's view of the typical, orderly New England community, clearly his impression of the New Hampshire where he was in residence. Here, he appears to admit a reluctant admiration while commenting that it was also dull, even chilling. By contrast, Hispano-America, the Mexico he had left behind, was vital, tumultuous, dramatic, utterly corrupt, and demanding rebellious overthrow by the hero-peasant.

It is only in the panel *Stillborn Education* (or *The School Teacher*) that Orozco does not savagely attack the evils of the modern order. Perhaps this was to heighten by contrast his attack in the pendant *Hispano-America*. In any case, he let loose with redoubled fury in the *Gods of the Modern World*, which concludes the east wall (fig. 26). The references could hardly be more site-specific. A row of skeletons in academic regalia watches a colleague receive a grotesque skeletal fetus, with mortarboard, who is being delivered by a writhing skeleton disgorging books and fetuses in bell jars. Behind the rigid academic row the world is in flames. The pomp and intellectual sterility of such institutions as Pomona College and (can it

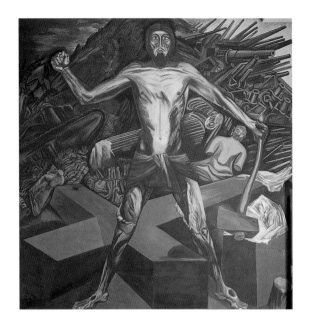

Fig. 27. José Clemente Orozco, *The Epic of American Civilization: Modern Migration of the Spirit* (Panel 21), 1932-34, fresco. Commissioned by the Trustees of Dartmouth College, Hanover, New Hampshire.

be?) his host, Dartmouth College, are castigated in the very temple of dead knowledge, the library.

On the north and east walls, in four successive panels, Orozco calls for the rejection and destruction of the modern order—the social order (Mexican panel), intellectual order (academia), political, and spiritual. The idea of ending *The Epic of American Civilization* with such a resounding reiteration of his destruction theme had apparently grown on the artist as the cycle progressed. His preliminary project for the end panel of the long wall had for its theme *The End of Superstition—Triumph of Freedom*. This could be viewed both as a complement to Dartmouth's academic liberalism at that time and as the sign of hope to come, which had been the implied or implicit end of his two earlier American cycles. It is significant, in view of Orozco's darkening vision, that the Dartmouth cycle was to end not with a gleam of hope but with a mere glimmer.

The east wall, with its *Modern Human Sacrifice* and *Modern Migration of the Spirit* (fig. 27), corresponds, in themes and on axis, to the introductory, ancient-world subjects of the west wall. A skeletal Unknown Soldier is glorified by a bombastic politician and the blaring of brasses. The political glorification of war, with its hypocritical human sacrifice, is treated in a manner reminiscent of Orozco's earlier cartoons. What the panel loses in formal expressiveness, it gains in impact from comparison with the bloody public rituals of the pre-Conquest Aztecs in the corresponding panel, on axis, on the west wall.

The impact and the message of the second panel are very different. It presents a violent, even astonishing image, pregnant with complex meanings. It closes the east bracket of the long line of episodes that cover the three main walls of the room and serves as a partial ending, if not the last word, of the Dartmouth cycle. The Byzantine, partly flayed Christ figure—an ageless image—stands with a clenched fist and an axe in hand before a junk heap of the symbols of Eastern and Western religion, mechanized civilization, and modern warfare. It

Fig. 28. José Clemente Orozco, *The Epic of American Civilization: Ideal Modern Culture II* (Panel 23), 1932-34, fresco. Commissioned by the Trustees of Dartmouth College, Hanover, New Hampshire.

suggests a Last Judgment. Christ's message has been perverted throughout history and he calls for an auto-da-fé of all false orders of the past. It is the resounding, apocalyptic climax to the four destruction episodes that close the *Epic*.

But is it indeed the Apocalypse? Is Orozco's dark message totally black? Was the fresco darkening as he painted progressively down the wall and redesigned the concluding episodes? His initial concept of the two east wall panels shows early explorers, settlers, and the founding of Dartmouth College, a bright promise for the future. By contrast, the *Modern Migration of the Spirit* is frightening, almost despairing. At the same time, it is a pendant to the axial *Ancient Human Migration* on the west wall that was the beginning of a story with seeds of hope. The higher force came with Quetzalcoatl. Is not the judgmental Christ again the hero-emissary from above? No descending light is shown, but Christ is destroying old orders to make possible a new "Migration of the Spirit," and we are seeing the suffering hero, the Christian Prometheus. There is implicit the concluding theme of hope which by my thesis rounds out the philosophical underpinning of all three American murals.

The cycle of large paintings closes at Dartmouth with the appearance of the judgmental Christ, but there is a coda. On the fourth wall of the room, opposite the reserve desk, a central door and bookcases are surrounded by panels. Here, in the panel titled *Ideal Modern Culture II,* modern industrial man appears as a productive and constructive laborer, and, over the door, as a recumbent figure reading a book (fig. 28), reminiscent of the books on the home table at the New School that symbolize the way to knowledge, corresponding to the enlightenment brought from heaven by Prometheus and Quetzalcoatl.

In the great scheme of the Dartmouth murals, these muted coda panels present hope as a glimmer, not a glow. Nevertheless, they corroborate my thesis that all three of the American murals reflect Orozco's philosophic credo, first expressed as the guiding idea of the *Prometheus*, that (1) inspiration is offered

from above through (2) the hero to (3) the masses, for them to accept or reject; (4) a painful destruction of the past is required, but (5) there is, if one looks for it, a sign of hope for the future. It may be only implicit, it may be only a glimmer, but it unites the three American murals. Subsequently, after his return to Mexico, Orozco would leave his viewers without even that comfort.

The violence of Orozco's protests against man's inhumanity seemed perhaps excessively strident in the United States of 1930-34. We were an isolationist country then, and although Depression conditions were indeed sad, they were not apocalyptic. But Orozco "revisited"—after the atomic bomb, after sixty years of world crises in which we become increasingly involved, after the recent horrors of Somalia, Bosnia, Rwanda, and Haiti and particularly in light of the recent terrorist attacks on our own country—presents a message that is more than ever pertinent to our times. How fortunate we are to have this message in Claremont, still burning clearly, in the *Prometheus*.

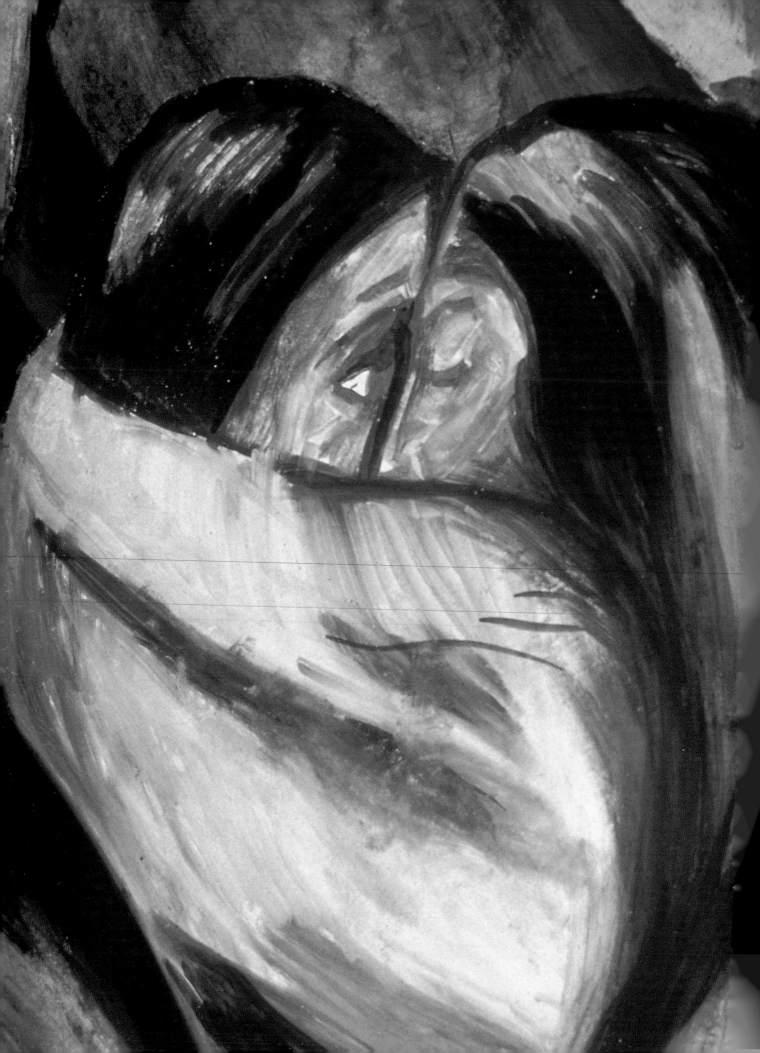

Mysticism, Revolution, Millennium, Painting

by Renato González Mello

ALMA REED, José Clemente Orozco's friend, promoter, and biographer, wrote that, toward the end of 1929, Mexican writer Agustín Aragón Leyva and Jorge Juan Crespo de la Serna, a Mexican painter living in Los Angeles who ultimately worked as Orozco's assistant in Claremont, convinced José Pijoán, professor of art history at Pomona College, to invite Orozco to paint a fresco at that institution. According to Aragón Leyva, Pijoán had had Diego Rivera in mind; instead Leyva swayed Crespo, and, later, they both convinced the Catalonian professor that Orozco was the right man for the job. [1]

Pijoán apparently discussed with Crespo de la Serna the possibility of commissioning a Last Supper, with "[…] an Indian Christ and St. John … along with the other apostles." Such a project might have been inspired by Orozco's murals in the National Preparatory School in Mexico City; in the first version of those frescoes, destroyed by Orozco himself in 1926, there was a panel depicting *Christ Destroying His Cross* (fig. 30). However, Orozco's iconography apparently concerned Pomona College officials,[2] including controller George S. Sumner, who suggested to President Charles Edmunds that color sketches be presented for consideration before approving any painting;[3] the Claremont community, headed by a local pastor, also made known their objections.[4] The myth of Prometheus, which was ultimately chosen as the subject of the mural, made no reference to the painter's Mexican nationality. It did, however, reflect another of Pijoán's ideas—a "Hall of Giants,"[5] quite possibly inspired by the early 16th-century Sala dei Giganti painted in Mantua by the Italian Mannerist Giulio Romano; as an art historian who revered Italian painting, Pijoán might well have thought of this as a source.

The *Prometheus* fresco is located on the main wall of the nave of Frary Hall at Pomona College in Claremont, California, a student refectory that resembles

Fig. 29. José Clemente Orozco, *Prometheus*, 1930, central panel (detail), Pomona College, Claremont, California.

47

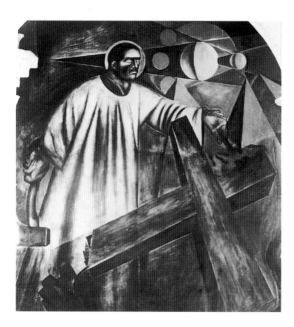

Fig. 30. José Clemente Orozco, *Christ Destroying His Cross*, 1923–1924. Preparatoria, Mexico City.

an austere Gothic chapel. This wall is found in what would be the presbytery of the nave, separated by a platform, which serves as support for a chimney. The moralizing intentions of the work are evident, and we can think of Orozco's mural as the sacred and edifying reading delivered in a monastic dining hall during communal dinners. Heavy, rectangular oak tables and chandeliers adorned with spikes enhance the hall's monastic mood.

The center of the mural is occupied by the Herculean figure of the hero (fig. 31), reminiscent of the grandiloquent style of Michelangelo's well-known *Belvedere Torso*. On either side, two rows of figures look toward the center and advance toward Prometheus. In the background, fire cascades from the sky forming a gleaming dome in the darkness. The principal composition is accompanied by three panels, two lateral, the third on the ceiling. The lateral panels depict *Zeus, Hera, and Io* on the left (west), while the right (east) shows *Centaurs in Agony* (figs.15-16). On the ceiling, Divinity is represented as an abstract prismatic form, irregular and broken (perhaps as a consequence of the Promethean rebellion) (fig. 14). A broader iconographic scheme might have included Uranus, Gaea, and Oceanus, as well as the gods battling the giants, and this suggests that Orozco's inspiration came from the Hesiod's *Theogony* in which the Promethean myth is described.[6]

Prometheus is shown at the moment of committing his outrageous act, stealing the fire that Zeus had denied mankind. The fire scatters over the earth, surrounding the hero. To his right, the figures look downward, slipping away in an unconscious procession; one, in the foreground, confronts Prometheus; there are two lovers, indifferent to the chaos; one man stabs another. In contrast, to his left, the masses look upward and raise their arms toward the demigod. To the extreme left, one figure helps another rise. This portrayal of a divided humanity gives the mural a sense of the apocalyptic and introduces a fundamental relationship with two themes of Christian iconography: the Anastasis, in which Christ descends from Purgatory to liberate Adam, Eve, and other characters of the Old Testament;[7] and the release of souls from Purgatory and their elevation to Heaven, frequently with the assistance of saints; the latter is a particularly popular devotion in Guadalajara, where Orozco spent his childhood.

In the *Prometheus* mural, Orozco employed cultural symbols of enormous prestige: Greek sculpture and mythology, Byzantine painting, and Gothic architecture, all brought together in an eschatological story. Before such classical and historical references, it is no surprise that an awed Arthur Millier, art critic of the *Los Angeles Times*, wrote that: "The aesthetic experiments of modern Paris are trivial compared to the Mexican mural paintings made during the last nine years."[8] This opinion reflects a point of view that appreciates mural art because it is different from that of the European avant-garde: because it relies on the traditions of the

art academies; because it does not separate ethics from art but, rather, uses art as a vehicle for public discourse. The success of Mexican muralists in the United States owes much to the distinction between their art and that of the avant-garde (a comparison they sought from time to time), to the fact that they were modern painters who did not neglect tradition or the integration of their work with traditional architecture, that they did not believe in "art for the art's sake" or in the revolutionary concept of formal purity but, rather, used revered traditional techniques such as fresco painting. Orozco's fresco seems to use composition as an expression of humanism in that it emphasizes the disposition of the figures on the surface of the painting as much as the suitability and decorum with which history is narrated. This is history painting that, as mandated by the academies centuries ago, was inspired by classical mythology for the purpose of encouraging discourse about truth, knowledge, and heroism.

Fig. 31. José Clemente Orozco, *Prometheus* mural, central panel, 1930, Pomona College, Claremont, California.

I would argue here, however, on the basis of the intellectual sources of the painting and its preparatory drawings, that the *Prometheus* can be only partially explicated according to the aforementioned point of view. This is, most assuredly, a work that used all of the resources instilled in the painter at the Escuela Nacional de Bellas Artes (then known by its original name, the "Academia de San Carlos"[9]); it is not a work of art that can be explained by means of a theory of the avant-garde, like those developed since Dada, Expressionism, and other European avant-garde movements.[10] It is, rather, a work of art that uses academic composition, academic iconography, and the genre of academic "history painting" to subvert the hierarchy and assumptions implicit in these sources.

The Delphic Circle

The literary sources of the fresco have already been widely noted, and only a brief synopsis can be given here.[11] In his first murals, Orozco opted tirelessly for an iconography of Masonic or theosophical origin, in almost all instances esoteric in nature. For example, this is evident in his 1925 fresco in Sanborn's Restaurant in Mexico City (fig. 32). Its title, *Omniciencia*, refers to the end of the Masonic initiation: to a universal consciousness, free of passions, and useful for the domination of the world. The concept exists in a handwritten manuscript by the painter:

—A wall in the background—
Two large figures:
The spirit and its form: matter.
Both sides of the whole: the masculine principle, the creator, aggressive and eternal.
The feminine principle, charming, delicate, and always in wait.

49

He gives—She receives.
The central figure—simultaneously, wisdom and grace.
Figures bound to the first two:
Destiny
The higher power, unknown (the head cannot be seen), which is the divine origin of Mankind, God of Gods: These figures also have human form; Man creates and destroys Gods as he pleases!
Upper part: secondary decor
The gift.
Powerful hands offer other hands the sacred fire. [12]

We must add to the painter's description that both masculine and feminine principles, representations of activity and passivity—an opposition dear to modern esotericism—arise on wild, rocky formations. Virtue rests on a well-polished seat, one of the most immutable symbols of the Masonic order, used to portray the pursuit of spiritual perfection by those newly initiated.

During his stay in the United States between 1927 and 1934, Orozco was represented by Alma Reed, a journalist and aficionado of archeology. Reed was also the secretary of Eva Palmer-Sikelianos, who, with her husband, the Greek poet Angelos Sikelianos, shared the concept of creating a universal "Delphic movement," a form of socialist utopia reminiscent of the nineteenth-century French Saint-Simonians. This movement proposed the establishment of a new ideology that would unite emerging nations in the years between the wars. At the same time, the Delphic creed proposed establishing an intellectual aristocracy that would take charge of social energies and change. [13]

Eva Palmer-Sikelianos hosted soirées of musicians, intellectuals, and artists, later referred to as the "Delphic Circle" or "Ashram," at her home near Washington Square in New York City. During his sojourn in New York between 1927 and 1930, Orozco was initiated into this theosophic brotherhood in a ceremony in which he was baptized and crowned with laurels.[14] There, he associated with a large number of prominent intellectuals, among them, Charles Leonard Van Noppen and Emily Hamblen, who was the author of an essay on Nietzsche.

A poem by Van Noppen, a faithful participant in the Delphic Circle and attendee of the soirées, touched on the controversial topic of the resurrection of the dead:

Come, all ye living, camp against the dead.
Go forth and give them battle who have sold
The future into bondage [...]
[...] Slay, oh slay
The tyrant Past. Awake, for the day dawns! [15]

Alma Reed affirmed that the poem was closely related to the Pomona College fresco, and this reinforces the relationship of the *Prometheus* to Christian eschatology suggested above.

One of the fundamental activities of the movement led by Angelos Sikelianos was the organization of the festivals at Delphi. Their purpose was to

acknowledge the Anfictionic League and thus call for the unification of Orient and Occident. Eva Palmer-Sikelianos was the primary organizer and hostess of these Delphic festivals. The first event, in 1927, included a staging of Aeschylus's *Prometheus Bound*; three years later, another, *The Supplicants*, was performed. Both dramas featured a chorus with music arranged in a Byzantine style.[16] The Delphic festivals also included a fair of Greek regional handcrafts and, on one occasion, gymnastic exercises performed by the military. Alma Reed's recollection of the first festival comes to mind:

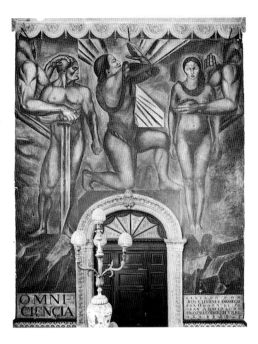

Fig. 32. José Clemente Orozco, *Omniciencia*, 1925, fresco, House of Tiles (Sanborn's Restaurant) Mexico City.

> Standing on the Promethean rock where Aeschylus's drama had been staged, Sikelianos narrated how, a few hours ago, in Arachova, he had been walking on the sacred ground, where the decisive battle to liberate the Greek people from the bitter oppression of centuries had taken place. "But for a people to be truly free," he warned, "it is not enough only to free ourselves from national oppression. It is also necessary to cast off the spiritual yoke that, for centuries, and vainly, in relation to our pure spiritual heritage, has been imposed on us."[17]

A poem by Angelos Sikelianos titled *The Fates*, which Orozco remembered, significantly, as *A New Generation of Gods*, also translated into English by Alma Reed and later into Spanish by Orozco, described the dream of an initiate intoxicated by "the honey of the earth":

> And in its reflection
> I suddenly noticed, all around,
> a whole generation of gods
> looking at me thoughtfully.
> Then,
> As if at the cusp of an endless night,
> There burned inside of me,
> the prophetic flame of desire. [18]

Perhaps none of the members of the Delphic circle was as meaningful to Orozco as Emily Hamblen, who was the author of an essay on the philosophy of Nietzsche and who interpreted the painter's work—especially the New York scenes—within a Nietzschean framework. Jacqueline Barnitz suggests, with reason, that the *Prometheus* at Pomona College is a Nietzschean hero, taking into account that it was Orozco's first work in which the character is superimposed on a crowd conceived, in a modern sense, as a mass.[19] Hamblen, like Sikelianos, believed that culture was the product of exceptional men: Nietzsche, Blake, Whitman. At the opening of an informal exhibition in the Ashram, she presented

a lecture in which she also compared Orozco with William Blake, equating their work with her perception that "[…] the spirit of man, lashed by the wind [...] with an excessive development of the reasoning faculties, has changed his lifestyle and his customary relationships with fellow man, and apparently, even with his gods; this confused spirit has not yet been well depicted in art."[20] In Hamblen's opinion, Orozco was among the initiates who best succeeded in capturing this "confused spirit." Fascinated by irrationalism, she dedicated the most important part of her work to Blake, who aspired to construct a poetics as well as seek universal knowledge.[21]

In Orozco's mural, the fire is celestial. On either side of the hero, humanity is divided. Sikelianos's poem, evoked by the painter as well as by Reed, his promoter, offers much food for thought. *The Dedication* interprets the manifestation of the object of worship during an esoteric initiation:

> And lo, I was as one exhausted, who, caught by a sharp winter, finds a fire and wholeheartedly seated before it
> Looks dumbly at the flame and dumbly stretches his cold hands to where the glow is strongest. [22]

The beginning of the poem was Blakean in nature: it did not disdain communion in the name of orphic mystery. The path traveled by the "initiated" would exclude neither the macrocosm nor the microcosm (i.e., neither the intellectual nor the material world), and the aspiration would be, in the end, to erase that difference:

> No heed he gives to that which is near or to that which is far, for now the whole earth lies beneath his every step. [23]

In Orozco's *Prometheus* mural, the fire divides the masses; it promotes passion and hope, but also rage and desire. It does not bring man closer to rational divinity; rather, it provokes a confrontation. The poem's title was, as Orozco remembered it, "A New Generation of Gods," that is, conceived as attached to the earth and to desire; it makes us think of Zeus's rebellion. This "new generation" was going to be the consequence of desire as well as war, which complement one another here. On the left side, next to the figures in flames, the gods appear on a lateral panel. On the right, where the "flame of desire" prevails, where the lovers incessantly embrace, and where one character stabs another, the lateral panel portrays chaos: centaurs attacked by serpents, men who have walked the evolutionary path backward, who have become emasculated and are now prisoners of the earth. [24]

It is possible to compare this mural with *Omniciencia*. In both cases, the gift of the fire is addressed; but at Pomona College, the gift of water is no longer conceived as being on the same hierarchical level. In both cases, opposing principles are represented on the sides of a monumental central figure; however, at Pomona, they are no longer individual figures but, rather, masses that are at times languid. In both cases, the central figure summarizes the contradictions of the symbolic language, but in *Omniciencia*, Grace harmonizes these oppositions, while

at Pomona, Prometheus confronts divinity and becomes the center of a contradiction in the world. Both works use esoteric content, but, at Pomona, this is not so obscure as to require a dictionary. The allegory is transparent; it stresses certain symbols, especially the body of Prometheus, but also the confrontation with the gods (Heaven and Earth, the Macrocosm and the Microcosm).

The *Prometheus* portrays a humanity divided in two, surrounding the hero. Sikelianos, throughout his projects and exhortations of the Delphic movement, believed that among intellectuals around the world, there were energetic and enthusiastic men with the potential to devote themselves to the sanctuary of Delphos. Orozco's mural separates these chosen ones from the masses, which, Sikelianos says, find themselves painfully segregated from the elite by virtue of the established ideologies of the time. Separation is an important element of Orozco's symbolism, as David Scott's groundbreaking article has established, as are communion and unity.

Choreography

Sketches for versions of Orozco's *Prometheus* mural other than the one ultimately painted are not known. The majority of the drawings recently acquired by Pomona College coincide closely with the composition and individual figures of the Frary Hall mural. If Orozco sketched alternative ideas, he kept primarily those related to the final version of the mural.[25]

This absence of drawings showing rejected ideas and different approaches is not consistent with most of Orozco's mural work for which sketches that did not lead to the final painting have been identified.[26] Orozco's working process was complicated, and, frequently, his first sketches for compositions would eventually be completely changed. In some cases, completed works were later redone: for instance, the panels he painted between 1923 and 1924 on the lower level of the National Preparatory School were replaced in 1926. There are reasons to believe that the resolution of the *Prometheus* was less arduous. Orozco had little time to work—only from March through June of 1930.[27] The anatomical details, which frequently diverted the course of the composition, leading to a radical rearrangement, coincide both with the general sketch and with the final painting. There is a theatrical analogy here: the sketches were the equivalent of a perfect rehearsal.

The general sketch (fig. 33) gives us a clue to understanding Orozco's process: a set of compositional lines converges on the lower abdomen of the central figure, making the body of the demigod the center of gravity for the entire composition. This produces a counterpoint: since the arch points upward, the composition converges on a center that, despite the careful determination of proportions, is ultimately arbitrary. The body of Prometheus is the measure of all proportions. The force lines of the composition impose a geometric order on the pointed arch: they begin proportionally but extend to imaginary points outside the arch itself. Orozco cut off the base of the panel with two converging

lines on the central axis that point downward. In the mural, only one of these—on the left—is visible.

This composition was conceived to bring about a delicate relationship between painting and architecture. In 1947, reflecting on his manner of painting murals, Orozco affirmed that there were two basic approaches: "a) Preserve the architecture, or b) Destroy the architecture." [28] At Pomona, however, he did something different: he modified the architecture. The importance he gave to the central panel, emphasized by the torso and right leg of Prometheus, mitigates considerably the verticality of the pointed and widened arch, overwhelming its symbolism and reducing it to its constructive values. At the same time that it points upward, the composition illustrates the gravitational pull that sustains the two halves of the arch. The V-shaped design at the base, also evident in the drawing, softens its tectonic appearance, discreetly lifting the bases of the arch like a ballerina lifting the hems of her skirt. This makes Prometheus's left foot act as a support and gives the impression that the figure is pushing against the right side of the arch. The gesture with which Prometheus covers his face is ambiguous but consistent with the painting as a whole. There is a tension between the architecture and the geometry of the painting that makes Prometheus's body the center and the rationale for the entire composition: it brings hints of epic proportions, even though it cannot be clearly determined if the character is actually challenging or resisting. This generates an irresolute ambiguity at the most elemental level of representation, and this lack of definition extends to the iconographic and symbolic level, just as the sides of the arch appear to be the impossible expansion waves of an implosion. This is a question, beyond all paradox, of a constructive demolition.

The motive behind this complex composition can be found within its ambitious design. The *Prometheus* makes us think of the importance that classical treatises on painting bestowed on the representation of the human body as measure and model of the universe. Orozco had been trained in the Academy. The tense, striving body of the hero brings to mind Mexican symbolism from the beginning of the century, a line of thought already explored by David Scott. But the *Prometheus* introduces in Orozco's work an image that is new in his murals (although not in his drawings and cartoons): the masses. It was this iconographic innovation that led him to this complex composition and brought about in this case, if appearances are not deceptive, strict adherence to a predetermined geometry. The contrapposto of the central figure emphasizes its already remarkable monumentality, but it is impossible to overlook the figures in the foreground, that appear to perform a choreography with no center. They turn and point, they twist and duck, they look up and move away from the hero, they let go and fall, or raise their arms with determination; they bend and lean to give their steps more strength; they stab, they beg, they embrace, they challenge.

The composition is a device to assure a coherent narrative that turns out, in this case, to be paradoxical. Orozco was aware of Eva Palmer-Sikelianos's experi-

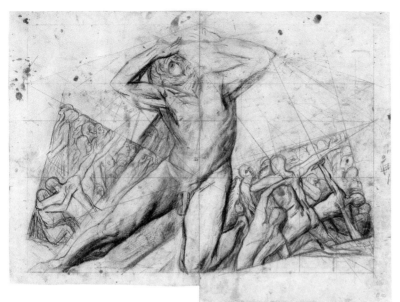

ments with the theatre of the masses in Delphi and doubtlessly gave much thought to the relationship between the "chorus" and the "protagonist." In his mural, however, the chorus is integral. It is not the protagonist, but at the same time, it does not murmur quietly behind the hero's back. The hierarchy of the elements has changed: it is now the masses at the hero's back that have a destiny; it is the masses, not Prometheus, that allow us to speak of "tragedy."

Fig. 33. José Clemente Orozco, Study for central panel, *Prometheus* mural, 1930, graphite on paper, 17 5/8 x 23 3/8 in., Pomona College, Claremont, California.

Mass and Drawing

Although it may seem that the *Prometheus* originated in the dramatic project of the Sikelianoses, the resulting work differed substantially from it. The theatre of the masses with which Eva Palmer-Sikelianos experimented, is, in this case, the origin of the image of the masses. However, this iconographic innovation is not narrowly related to the ideals of "people" and "nation," as in the Delphic project. The masses beside Prometheus are neither popular nor national: they do not represent social life, but, rather, have a significance that is, once again, closer to Symbolism. Its presumed universality merits an explanation, which once again takes us back to the preparatory drawings.

In the sketches for the mural, Orozco practiced a form of drawing he learned at the Academy, although his interpretation was, at times, unorthodox. From the 18th century on, students of the Mexican Academy were obliged to follow a painful path to learn the art of drawing. They began by copying engravings or their professors' drawings; they then used as models casts of sculpture that the school had collected since its founding. Subsequently, students were allowed to use live models, and, finally, they would progress to composing their own works. Step by step, students were challenged to move from the simple to the more complex: first reproducing details—hands or feet—and only then, entire figures. With variations, which at times included the use of photography as "evidence" of the successful realization of an image, this curriculum lasted from the founding of the Academy until Alfredo Ramos Martínez became director in 1913. [29]

In 1903, the Pillet system was adopted, which consisted of teaching drawing using flat geometric shapes, then reproducing perspectives lighted from different positions. Objects were drawn from nature, although the human figure was still undertaken using casts and photographs. Also in 1903, the Catalonian professor Antonio Fabrés implemented a new method of training that favored drawing "from life," that is, using live models in different positions and seen from different angles. [30] Fabrés favored drawing live models over the arduous traditional methods of learning anatomical drawing. After his departure, according to numerous witnesses, his students substantially changed his teaching techniques.

Fig. 34. José Clemente Orozco, Study of raised right forearm and fist, preparatory drawing for *Prometheus* mural (central panel), 1930, charcoal on paper, 11 3/8 x 6 1/4 in., Pomona College, Claremont, California.

The models no longer stayed in the same position day after day. The drawings were very detailed but were made a lot faster in order to train both the hand and eye. The new exercises consisted of reducing the time it would take to reproduce a live model or object, thus resulting in very quick sketches, in a matter of minutes, and later resulting in the ability to sketch and paint live moving objects. Photography was no longer used as a tool of comparison, and the forced simplification of such instantaneous work developed each student's unique style. [31]

In his pioneering article about Orozco, José Juan Tablada explains the procedure. "He told me that he drew a lot using live models at the Escuela de Bellas Artes, avoiding academic techniques, focusing on observing moving models and objects, creating an impression, observing, storing it in order to paint later."[32] We know that during his first years in New York, Orozco drew Park Avenue habitués in a sketchbook. [33] In 1931 he suggested that Jorge Juan Crespo, his assistant at Pomona College, go out on the streets with paper and pencil, to draw "from life as well as memory."

Keep in mind that you are a student of the Academy, under the influence of a strict academic professor. You will see that the results will have nothing academic about them. [34]

This recommendation was made under the assumption that speed, the use of simple tools, and the restriction of thought would restrain any student from modifying whatever his personality dictated while drawing.

This practice, to which Orozco was almost always loyal, did not seem to apply to his drawings for the *Prometheus* mural that have recently been acquired by Pomona College. Although these are full of fragments, especially hands and arms, the drawings relate more to a preconceived plan than to a search for an individual, uncompromising, and expressive style that relied on speed and direct observation. The studies of hands have freedom and strength in their lines, but only within the context of the composition and their function within it. It is probable that a number of unknown preparatory drawings exists, but drawings like the study of a raised arm and fist (fig. 34) and the study of two raised arms (fig. 35) were used in the mural to resolve specific figures of the masses behind the hero. Orozco also probably produced numerous sketches of Prometheus's torso and general anatomy, many more than those known to us.[35]

The preparatory sketches are, from an anatomical point of view, as detailed as, or even more so than, the figures in the mural. Figures that appear loose and free, occasionally even caricature-like, in the final painting were based on detailed anatomical sketches. This is an inversion of the order that Orozco proposed in his autobiography: first comes the project, then the anatomy, and, finally, the "simplified" drawing which lets us see the "personal style."

This relationship between Orozco's preliminary drawings and his painting affects the meaning of the mural and, above all, of the masses. Between Prometheus and the chorus of unfortunates exists all the distance that sepa-

Fig. 35. José Clemente Orozco, Study of two raised arms, preparatory drawing for *Prometheus* mural (central panel), 1930, charcoal on paper, 12 ¹/₁₆ x 9 ⁹/₁₆ in., Pomona College, Claremont, California.

rates the conventions of pictorial and graphic representation. Both rely on corporeal expression—especially the position of their arms—to establish their place within the scene. But whereas Prometheus's body seems (but only seems) to reflect strict academic influence, the other figures diverge progressively from that norm. All of the figures are arranged according to a careful geometric framework, those in the foreground following each other front to back, gesturing as if performing a Mannerist choreography. But as the eye moves toward the back of the work, the careful disposition and meticulous construction of the scene give way to a different kind of representation. The bodies appear fragmented. Hand gestures practically turn into calligraphy.

This drawing and quartering is essential to the creation of a relationship between the body of the hero and the masses in a social body. And this procedure correlates with a Prometheus who, observed closely, does not display the harmony commonly attributed to man as microcosm, diagram of the cosmos and model of divine rationality. This human form seems to have slightly twisted legs, and the right appears to have been forced into the hip. The contrapposto is violent, the proportions are somewhat unusual, and the muscular effort is colossal.

This innovation relates to the distinction between Orozco's own pictorial art and the populist dramatizations of the Sikelianoses. In Orozco's mural, there are no garments, signs of identity, or uniforms. This is not a chorus of a gymnastic society or an army battalion executing mechanical movements (as was the case in the dramatic staging of *Prometheus Bound* by Sikelianos), although it does refer to an organism that reorganizes fragmentary anatomy. The artist wanted a representation of the masses that omits commonplace reflections of identity—notably in the Mexican example, cactuses, sombreros, sandals, magueys, a landscape with volcanoes, and the "Indian Christ" that Pijoán had proposed. During his stay in the United States, Orozco frequently resorted to this nationalistic iconography (fig. 36). But at Pomona College, the omission of these themes led him subtly to pose once again the symbolic value that his intellectual convictions and painting practice led him to accord the human body.

Desire and Prophecy

Prometheus's plunder is a fire that descends to the world and sets in motion a mechanism whose catastrophic end seems imminent. Angelos Sikelianos's poem, recalled by Orozco, speaks of "the prophetic flame of desire." The poetry of William Blake, recalled by Emily Hamblen in relation to Orozco, makes the same reference. And the close relationship between prophecy and desire imposed by Western patriarchal thought opens the door to mysticism.

Developed in the context of the rise of fascism and Stalinism, the financial disaster of capitalism, intense ideological debate, and strong hope for (or fear of) a worldwide revolution, Orozco's mural demands a broader explanation than one limited to its sources and process. One should not interpret the complex symbolism that he proposes with the same reductionist approach that is used

today to interpret the ideologies of the twentieth century. During the first decades of this century, mysticism and revolution were far from being opposing terms. Enlightenment, inner ecstasy, and social change were conceived as closely related. This had much to do with the esoteric doctrines of the day, as well as with the reinterpretation of a world that was changing in a different way from what bourgeois ideology—still closely related to nationalism—had anticipated.

In 1934, Vicente Lombardo Toledano, the founder of official Mexican trade unionism in the 20th century, published a text titled "Open Letter to Jesus Christ."

> There is no single rebel. The masses are the rebels. They, Joshua, are your voice at a time when a stockpiling minority hoards all the material goods and is able to acquire all spiritual benefits as well. They will destroy the impure, the unjust; and they will achieve their happiness right here, in this life, and will make of it a garden like the Japanese who cover rocks with a carpet of flowers, filling with awe even those who believe in the impossible.[36]

The manifesto was published in *Futuro,* a journal edited by Lombardo himself. The same volume carried a brief note on Orozco's painting. Lombardo's "Open Letter" elaborated on the same themes as Orozco's mural, elevating the masses to the level of protagonists ("the masses are the rebels"); the apocalyptic references ("they will destroy the impure"); the ambiguously esoteric tone, and the attempted philological precision ("Joshua," of course, is Jesus Christ); and the proposal of a symbolic universe within an imaginary and universal periphery ("like the Japanese who cover rocks with a carpet of flowers"). In sum, it involves redefining the limits between public and private sectors. The letter to Jesus Christ is "open," even as Orozco's "public" mural is located in an ordinary space.

The distinctions between the images of the masses, leadership, and heroism slowly move away from the processes studied up to now by the historians in the twentieth century. George L. Mosse, in his study of national ceremonies in Germany, concludes that the new public mysticism initiated in Europe in the nineteenth century and culminating in the mass rituals of National Socialism, was "the concise realization of a new political religion."[37] Orozco's mural, Lombardo's letter, and an endless stream of testimonies by other twentieth-century Mexicans support the view suggested by Mosse, namely, that the political left saw itself forced to participate in the debate on the new cult of the masses, and even to create its own ritual.[38] In this context, Orozco was close to the Hellenistic leanings of Eva Palmer-Sikelianos, although he did not participate directly in the Delphic festivals. In February 1930, when the mural was taking shape, Orozco wrote to his wife: "As for the festivals in Greece, I know nothing about them, nor do I care." [39]

To understand the difference between Orozco's mural and the Delphic festivals, Lombardo's manifestos, and the viciousness of the fascist cult of the "masses," one must examine his drawings. Although the notions of "myth," "religion," and "mysticism" are appropriate to a discussion of the mural, the exactitude with which every figure is depicted underscores a focus on the concrete. This is crucial to a critical thinking rooted in the representation of the human

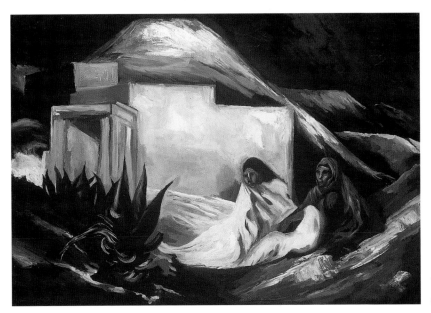

Fig. 36. José Clemente Orozco, *Colinas Mexicanos*, 1930, oil on canvas, 17 x 24⅛ in., Museo de Arte Álvar y Carmen T. de Carrillo Gil, Mexico City.

figure. In the cultural history of Latin America, it is common to look for a (usually difficult) compromise between conformity and subversion, between imagination and concrete action in the world. In Orozco's case, such action was inconceivable unless it originated within the limits of painting, which was his garden, his city, and his political universe.

This does not mean that it is an isolated political universe, but rather the reverse. Siegfried Kracauer noted that after World War I, all public discourse focused on the insignificance of the self and of individuality: reports from all parts of the globe narrated a universal history whose power rendered individual power laughable. For this reason, he reiterated that there was a crisis in the novel, because every narrative whose scope sought to go beyond the realm of the self would have found itself at odds with the pitiful insignificance of the individual.[40] Orozco sought a political distinction for his work through the representation of the human body: it is there that one can find its political meaning; it is there in the divided masses, in the dislocation of the heroic act of Prometheus, in the awkward placement and dissolution of his limbs, in the transformation of anatomical forms into graphic symbols, and in the human figures that parallel similar figures on the other side of the mural. Orozco represented a governed mass, divided and oppressed by external forces. But it is also there in what had been until then the crux of Orozco's painting—composition and anatomy—where its rupture with tradition and its critical reflection on the genre of classical history painting can be found. Orozco's mural is not avant-garde painting; however, it did subvert one of the strongholds of Mexican academicism: the painting of the body based on drawing from the live model. The *Prometheus* demonstrates Orozco's awareness of the predicament of modern individualism. To represent the individual, the painting shifts the crisis to the most dearly held academic prejudice: the belief in the profound rationality of human anatomy. It does so not by opposing a different system but, rather, by subverting anatomical convention—in all its Rodin-like monumentality—from within and to such an extreme that it dislocates the figures as well as their related symbols.[41] This critical grandiloquence—paradox intended—is what allows the work to speak of the world, speak to the world, and at the same time, to be its own world. This is where its critical strength can be found: in a political environment where the very notion of autonomy was seriously contested, the *Prometheus* is grounded in the negotiation of autonomy for the work of art itself.

This essay is dedicated to Fausto and Rita.

1. Alma Reed, *Orozco*, Mexico, Fondo de Cultura Económica, 1955, p. 183.

2. Luis Cardoza and Aragón, *Orozco*, Mexico, UNAM-Instituto de Investigaciones Estéticas, 1959, p. 277.

3. Laurance P. Hurlburt, *The Mexican Muralists in the United States*, Albuquerque, New Mexico, University of New Mexico Press, 1989, p. 33. There is no evidence, however, that preliminary drawings were presented to the College for approval before Orozco began painting the mural.

4. Azuela, "Presencia de Orozco en la sociedad y el arte anglosajones," in *Orozco, una lectura*, Mexico, UNAM-Instituto de Investigaciones Estéticas, 1983, p. 192.

5. Reed, *Orozco*, p. 201.

6. There is a ceremonial procession at Pomona College in which students, alumni, and professors pass candles, symbolizing the transmission of knowledge to new generations. See Hurlburt, *op. cit.*, p. 29.

7. The word "Anastasis" is used in reference to Christ's descent into Limbo, before his Resurrection, to liberate Adam, as well as all of the Just, and to bring them to Heaven. The legend comes from the apocryphal gospel of Nicodemus and can also be found in the *Golden Legend of* Santiago de la Vorágine. Luis Réau, *The Iconography of Christian Art* (tr. Daniel Alcoba), Barcelona, Ediciones del Serbal, 1966, v. 2, pp. 553-559, "La bajada al infierno de los justos." In Byzantine art, the Anastasis was an iconographic theme so important that it often substituted for the Resurrection. Hurlburt, *op. cit*, chapter 1, note 67 confirms that Orozco saw the Mistra painting exposition at the Delphic Studios prior to his departure for California.

8. Alicia Azuela, *Orozco, una lectura*, p. 211.

9. About the changes that occurred at the Academia de San Carlos, see Fausto Ramírez, "Tradición y modernidad en la Escuela Nacional de Bellas Artes, 1903-1912" in *The Art Academies* (VII Coloquio Internacional en Guanajuato), Mexico, UNAM-Instituto de Investigaciones Estéticas, 1985, pp. 209-259.

10. See Peter Bürger, *Theory of the Avant-Garde* (tr. Michael Shaw, foreword Jochen Schulte-Sasse), Minneapolis, Minnesota, University of Minnesota, c. 1984.

11. See David W. Scott, "Orozco's *Prometheus*: Summation, Transition, Innovation," *College Art Journal*, XVII, Fall, 1957 (reprinted in this volume); Fausto Ramírez, "Artistas e iniciados en la obra mural de Orozco" in *Orozco: una lectura*, pp. 61-102; Hurlburt, *op. cit.*, pp. 26-42; as well as the forthcoming essay by Karen Cordero, "Prometheus Unraveled: Readings of and from the Body. Orozco's Pomona College Mural," in *José Clemente Orozco in the United States, 1927-1934* (Hanover, New Hampshire: Hood Museum of Art and New York: W. W. Norton & Co., 2002).

12. J. C. Orozco, "Casa de los azulejos," unedited and undated manuscript. Special thanks to Clara Bargellini and Carlos Pellicer López for a copy of the manuscript. The document, along with others which I will later mention, can be found in the archives of the poet Carlos Pellicer Cámara. It is very likely from 1925, right after the completion of the only panels ever made. The accuracy with which they are described makes it impossible for them to be from an earlier period. As with other murals, Orozco made several sketches which vary tremendously from the final version. Raquel Tibol, *José Clemente Orozco: A Life for Art*, a brief documentary, Mexico, Secretaría de Educación Pública-Cultura, 1984, pp. 80-81, shows what is very likely to be the first sketch, which resembles one of Siqueiros's panels in the "Colegio Chico" of the Preparatoria. There are two figures hovering one over another. Another sketch, in the collection of the Instituto Cultural Cabañas, shows a woman on her knees, surrounded by cherubs; in this same collection are found the sketches of the final version (Renato González Mello, *José Clemente Orozco*, catalog of Orozco's art collection in the Instituto Cultural Cabañas, Guadalajara, Secretaría de Cultura de Jalisco, 1995, p. 100). Conversely, in his manuscript, Orozco talks about the lateral walls of the stairs as if they were unpainted, but does so with much less detail.

13. Angelos Sikelianos, *Plan Général du Mouvement Delphique; L'Université de Delphes*, Paris, Les Belles Lettres, 1929, p. 46.

14. José Clemente Orozco, *Autobiografía*, 3ed., Mexico, Secretaría de Educación Pública-Cultura-Era, 1983, p. 98; José Clemente Orozco, *Cartas a Margarita*, Mexico, Era, 1987, p. 138.

15. Reed, *Orozco*, p. 114. "Come ye living," published in Leonard Van Noppen, *The Challenge: War Chants of the Allies—Wise and Otherwise*, London, Elkin Mathews, Cork Street, 1919, p. 18.

16. Eva Palmer, *Upward Panic: The Autobiography of Eva Palmer-Sikelianos* (ed., intr, and notes by John P. Anton), Philadelphia, Harwood Academic Press, c. 1993, pp. 94-104, 130-150.

17. Alma Reed, "Poetas de la moderna Hélade. II y último," *México en la Cultura*, supplement of *Novedades*, Mexico, August 16, 1964.

18. Reed, *Orozco*, p. 158.

19. Jacqueline Barnitz, "Los años délficos de Orozco," en *Orozco, una lectura*, pp. 110-111.

20. Reed, *Orozco*, p. 64.

21. Emily S. Hamblen, *On the Minor Prophecies of William Blake*, New York, Haskell House Publishers, 1968, xiii, p. 395.

22. Angelo Sikelianos, *The Delphic Word: The Dedication* (tr. Alma Reed), New York, Harold Vinal, Ltd., 1928, p. 15.

23. *Ibid.*, p. 16.

24. See Bram Dijkstra, *Ídolos de perversidad; la imagen de la mujer en la cultura de fin de siglo*, Madrid, Debate, 1994, p. 257, about the centaur in symbolic iconography.

25. The same occurred with the ones that Orozco himself chose for the earlier exhibition in 1947: *Exposición nacional José Clemente Orozco: catálogo que el Instituto Nacional de Bellas Artes públic con motivo de la exposición nacional retrospectiva de José Clemente Orozco*, Mexico, Secretaría de Educación Pública, 1947, pagination varies.

26. Some can be seen in the catalog of the Instituto Cultural Cabañas, in Guadalajara: González Mello, *José Clemente Orozco*, pp. 95-129.

27. Orozco, *Cartas a Margarita*, pp. 197-210.

28. Justino Fernández, *Textos de Orozco*, 2nd ed. (recompilation of Justino Fernández, addenda of Teresa del Conde), México, UNAM-Instituto de Investigaciones Estéticas, 1983, p. 78.

29. Regarding academic teachings of art, see Jean Charlot, *Mexican Art and the Academy of San Carlos; 1785-1915*, University of Texas, Austin, 1962. Clara Bargellini and Elizabeth Fuentes, *Guia que permite captar lo bello. Yesos y dibujos de la Academia de San Carlos, 1778-1916*, Mexico, UNAM-Instituto de Investigaciones Estéticas, 1989, pp. 49-50, about the survival of the casts; and pp. 33-34: in 1930, Federico Canessi still accounts for the use of casts in the instruction of sculpturing.

30. Ramirez, "Tradición y modernidad...", p. 217. This article is the most complete recompilation of the pedagogic crisis that the Academy experienced at the beginning of the century.

31. Orozco, *Autobiogría*, p. 17.

32. Included in Teresa del Conde, *J. C. Orozco; antología crítica*, México, UNAM-Instituto de Investigaciones Estéticas, 1982, p. 16.

33. Reed, *Orozco*, p. 97.

34. Cardoza y Aragón, *Orozco*, p. 292.

35. See Marjorie Harth's essay in the volume, particularly fn. 8.

36. Vicente Lombardo Toledano, "Carta abierta a Jesucristo," *Futuro*, Mexico, January 1, 1934, p. 31. Enrique Krauze, *Caudillos culturales en la Revolución Mexicana*, Mexico, SEP-Cultura-Siglo xxi, 1985, pp. 325-326.

37. George L. Mosse, *The Nationalization of the Masses*, Ithaca, Cornell University Press, 1994, p. 207.

38. *Ibid.*, pp. 208-209.

39. Orozco, *Cartas a Margarita*, p. 184.

40. Siegfried Kracauer, *The Mass Ornament: Weimar Essays* (translated, edited & with an introduction by Thomas Y. Levin), Cambridge, Massachusetts: Harvard University Press, 1995, pp. 101-105.

41. I would like to thank Karen Cordero Reiman and James Oles for their observations on this mural, which I had originally misunderstood.

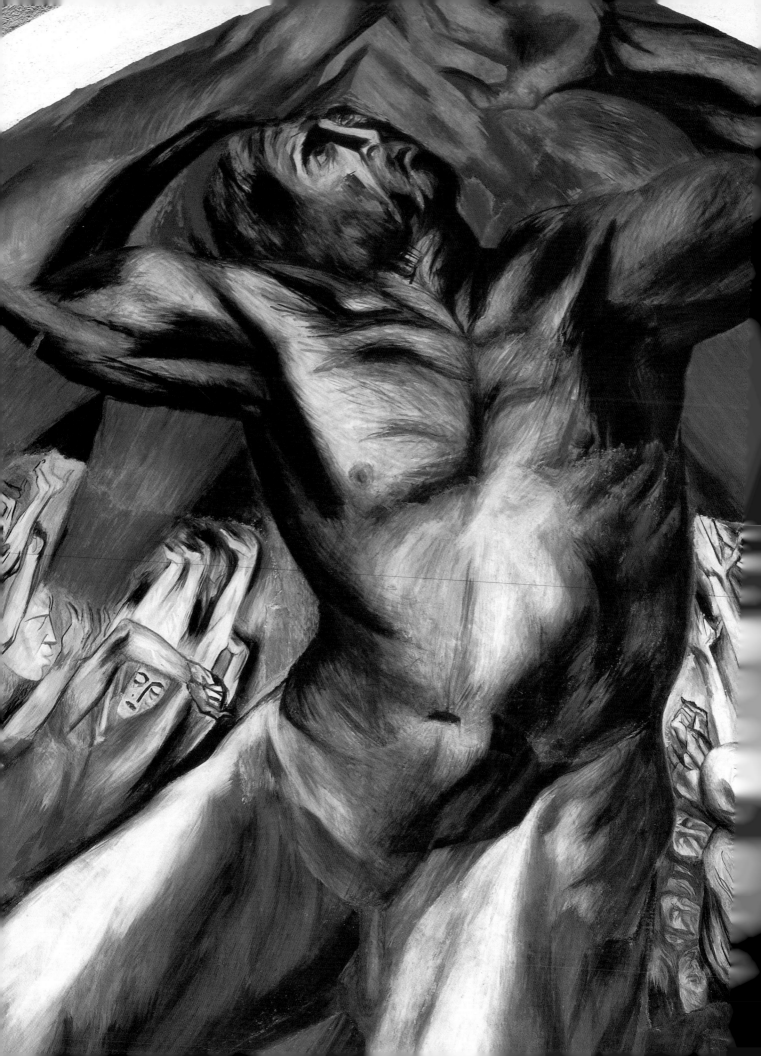

Promethean Labor
Orozco and the Gendering of American Art

by MARY K. COFFEY

¿Qué Es Mas Macho?

UPON APPROACH, José Clemente Orozco's *Prometheus* mural presents a resoundingly masculine gestalt. Whether read as aggressively affirming male identity or as pathetically compensatory, this monumental Titan energizes the monastic interior of Frary Hall with an existential heroism that has become synonymous with the post-World War II artist. No less a figure of creative potency than Jackson Pollock is noted for having referred to Orozco as "the real man" and for singling out this fresco (fig. 13), in particular, as "the greatest painting in North America."[1]

In terms of the image, we can attribute the semiotics of manliness, in part, to *Prometheus's* monumental nude form. Moreover, the spartan interior of the refectory enhances these assignations by providing a no-frills mise-en-scène in what was initially an all-male dormitory in architect Myron Hunt's original 1910 master plan.[2] Modeled after the ascetic purity of Franciscan mission architecture and the sober Gothic interiors of British universities, the wood-paneled dining hall marks a striking contrast to the intimate, domestic interiors of the women's dormitories located to its south. Orozco's effective use of this architectural support magnifies the demigod's towering physical strength. Indeed his image is so compelling that the architect himself reportedly joked that the building would collapse if the fresco were removed.[3] The fact that Prometheus also seems constrained, even oppressed, by the limitations this space imposes upon his striving gesture enhances the martyrdom emphasized in one of its possible literary sources, Percy Bysshe Shelley's *Prometheus Unbound.*

In Orozco's mural, the Renaissance ideal of movemented male nudity is inflected with the fin-de-siècle alienation of the romantic genius and refracted through the expressionist pathos of twentieth-century vanguardism. Yet all of these signifiers of masculinity might seem ironic given the figure's much-noted lack of genitalia.[4] Furthermore, unlike his Mexican peers—David Alfaro Siqueiros and Diego Rivera—Orozco himself was hardly a paragon of conventional

Fig 37. José Clemente Orozco, *Prometheus,* central panel (detail), 1930, fresco, 20 x 28$\frac{1}{2}$ ft., Pomona College, Claremont, California.

63

Fig. 38. Thomas Eakins, *Swimming*, 1885, oil on canvas, 27 3/8 x 36 3/8 in., Amon Carter Museum, Fort Worth, Texas. Purchased by the Friends of Art, Fort Worth Art Association, 1925; acquired by the Amon Carter Museum, 1990, from the Modern Art Museum of Fort Worth through grants and donations from the Amon G. Carter Foundation, the Sid W. Richardson Foundation, the Anne Burnett and Charles Tandy Foundation, Capital Cities/ABC Foundation, Fort Worth Star-Telegram, the R.D. and Joan Dale Hubbard Foundation, and the people of Fort Worth. (1990.19.1)

machismo. Not only was he without the use of his left hand, but his hearing and vision had been severely impaired in an accidental explosion during his teens. Art historian David W. Scott suggests that the artist identified with his protagonist, observing that both were wounded as a consequence of fire and that each felt condemned by the very masses he sought to illuminate.[5] Given this, it might be tempting to read *Prometheus's* ambiguous genitalia as a manifestation of castration anxiety. However, as it is very likely that Orozco painted a eunuch because of actual or feared pressures from the College, it might be more fruitful to attend to what cultural theorists call articulation rather than psychoanalytic formulations of sexual identity when considering the discursive relationship between the artist and masculinity in the United States at mid-century.[6]

Pollock's observation about Orozco provides a convenient point of departure given the centrality of the former's persona to postwar formulations of the artist. As Amelia Jones has argued, the "Pollockian performative" put in place a new model of artistic subjectivity that conflated the work of art with a normative masculinity naturalized through the critical discourse of Action painting and Greenbergian formalism.[7] Why, we might ask, did Pollock insist on the authenticity and exceptionality of Orozco's status as a man? In fact, why does the rhetoric of masculinity enter into the discussion at all? Certainly, the hairy-chested posturings of Thomas Hart Benton, the Rabelaisian antics of Diego Rivera, or the revolutionary stridency of David Alfaro Siqueiros would have been more obvious exemplars of "real man-ness." All were mentors of "Jack the Dripper," and thus surely part of the community of artists from which Orozco was isolated for distinction on this point.[8]

It should come as no surprise that Pollock, an abstract artist, would prefer Orozco's expressionist idiom to the narrative social realism of both Rivera and

64

Benton. Yet, I argue, it is more than Cold War aesthetic politics that secured this identification. Orozco's *Prometheus* functioned for Pollock as an index of the artist. Together, artist and mural provided a connotative link within a productive matrix of changing gender, labor, and cultural relations that culminated in the "triumph of New York" after World War II. Far from being the initiator of a virile identity for the American artist, Pollock was heir to a gendering process produced by the historical contingencies that forged the "American Century," namely: industrialization, war, depression, immigration, and class politics. My purpose here is not to argue for a simple cause-and-effect relationship between Orozco and Pollock, but rather, to situate *Prometheus* vis-à-vis an iconography and rhetoric of cultural labor that Pollock apotheosized and that Orozco, however unwittingly, helped to constitute.

From Gilded to Industrial Age

Pollock was not the first American artist consumed with crafting his vocation and persona as unassailably male. The artists associated with Abstract Expressionism did, however, succeed in this endeavor in ways that no prior individual or group had. The history of American art could be narrated, in part, as an anxious discourse about masculinity asserted over and against the ritual threats of feminization. Whether expressed as bourgeois, mass, consumer, or multicultural, the figure of woman has haunted cultural practitioners within the United States since at least the Gilded Age, if not much, much earlier.[9] To illustrate this point, I want to look to an earlier attempt to construct a masculine image for the American artist Thomas Eakins's *Swimming* of c. 1883–85 (fig. 38).

Randall C. Griffin has convincingly argued that Eakins's representation of idealized bathers in a modern Arcadia was an "assertion of the superiority of man as both principal maker of art and its ideal model."[10] A challenge to the late nineteenth-century dominance of the female nude, Eakins's image of homosociality countered the public perception of the effete painter with a vision of the artist and his students engaged in healthy exercise. Like Orozco (and many of the Abstract Expressionists, for that matter), Eakins looked to classical antiquity when crafting his visual manifesto on modern art. Both were trained within an academic tradition grounded in the study of the nude and both were convinced that ancient Greek civilization represented one of the pinnacles of Western culture. Eakins's Greece, however, was a culture refracted through a national preoccupation with health and fitness, wherein self-discipline and body maintenance were associated with reason and morality.[11] Thus his idealized athletes are youthful and fit, dispersed across the canvas in a friezelike array that mimics Greek sculptural relief. Conversely, Orozco's Greece was framed by the anti-positivism of Mexico's Athenaeum of Youth and the messianism of Eva Sikelianos's Delphic Circle.[12] Consequently, his *Prometheus* bears a greater resemblance to the anguished figures of the Hellenistic sculptor Skopas than the idealized youths of Athens. Nonetheless, because of their preoccupations with

classical antiquity, both artists sought to revivify its example through a resuscitation of the male nude, an extremely rare subject within the notoriously prudish visual culture of the United States.

The heroic nude male was each artist's answer to the erosion of gender boundaries and the perceived threat of societal feminization. For Eakins, the feminine embodied bourgeois complacency; for Orozco, mass culture. Throughout his oeuvre, Orozco relentlessly fashioned moral decadence and the degradation of modern life through the painted and diseased body of the prostitute. Like a diabolic machine, she is alluring on the outside but harbors deadly forces within. Women, in his art, never stand as ciphers of humanity as a whole and only rarely do they symbolize anything more virtuous than a victim. Rather, they represent the gluttony of the rich, the forces of ignorance and repression, or allegories of political corruption.[13] Conversely, political agency, the tragedy of human history, and the eternal strivings of mankind are represented by a pantheon of male figures drawn from both Christian and pagan histories (Christ, Quetzalcoatl, Zapata, and Cortés). In both form and content, *Prometheus* inaugurated Orozco's emblematic use of male protagonists in simplified, monumental compositions that register the artist's profoundly pessimistic and misanthropic world view. However, to understand how *Prometheus* signified within the terms of the twentieth-century Industrial Age, rather than the late nineteenth-century Gilded Age, we need to attend to the rapid changes in American art after the turn of the century.

The advent of the twentieth century intensified efforts to define a distinctly American art, and even the briefest analysis of the verbal and visual rhetoric of the nation's most vocal practitioners reveals the gendered terms within which this debate was framed. It is a cliché of the literature that the early twentieth century was polarized by the protean visions of the modernist Alfred Stieglitz and the "nativist" Robert Henri. While this dyad undoubtedly oversimplifies the period, it has a certain utility for a shorthand sketch of the first three decades of this past century.

Stieglitz is renowned for his efforts to bring European modernism to a still young and provincial American art world. Similarly, his promotion of photography as a legitimate form of modern art mirrored the Herculean task of acclimating a largely hostile public to the merits of formal experimentation and nonobjective painting. He described his cultural mission as "trying to establish for myself an America in which I could breathe as a free man."[14] Furthermore, his early descriptions of the photographer's practice are suffused with a heroizing tone wherein the stalwart artist submits to miserable physical conditions of interminable duration while stalking the ineffable. Recalling one such adventure, undertaken while sick with pneumonia, Stieglitz describes the bitter cold, his frozen mustache, stinging ears, and an hour's struggle against the wind on his return home. With regard to the resultant image of an ice-covered tree, he immodestly exclaims, "nothing comparable had been photographed before, under such conditions."[15]

Given cultural anxieties about the automating effects of technology and industry in the wake of America's Civil War and the nascent development of the assembly line, Stieglitz's insistence upon the critical role of the artist in photography is understandable.[16] However, I want to suggest that his emphasis upon the heroism of the photographer betrays anxieties about the masculine subject. Photography renders the artist passive in the act of mechanical reproduction. Furthermore, as the camera became cheaper and lighter, the privileges of class and gender that authorized the modern artist's social position were threatened by anyone who could point and click. Stieglitz admitted as much when he complained that "due to the advent of Eastman's mass-production methods, by the time I returned to America in 1890, it had become less exciting for the 'enthusiasts' to use their cameras, since 'everyone' was beginning to have them."[17] While the function of this anecdote is to lambaste the sorry state of New York's photographic societies before the advent of his *Camera Work*, viewed from this angle, his passion for the photographic cause may betray fears of emasculation as well as the loss of aura occasioned by the medium itself. Stieglitz's shift from the soft focus of pictorialism to the objectivity of "pure photography" in 1910 marks an important moment in the gendering of photographic aesthetics. It is no coincidence that pictorialism is overwhelmingly associated with female photographers, while its formalist antecedent, straight photography, is perceived as a predominantly male field.

Stieglitz's promotion of photography and modernist aesthetics is mirrored in effect by Robert Henri's agitations for a uniquely American painting. In his review of the 1910 New York Exhibition of Independent Artists, Henri surmised, "in this country we have no need of art as a culture; no need of art as a refined and elegant performance; no need of art for poetry's sake…What we do need is art that expresses the spirit of the people of today."[18] While Henri supported and encouraged his students, regardless of gender, his lectures reveal that, in his mind, being an artist was synonymous with being a man.[19] Just as European artists secured male privilege through the figure of the flâneur and his mobility within the leisured spaces of modernity (the brothels, dance halls, and bars of the Parisian demi-monde), the members of The Eight established a tacitly bourgeois male subject position through the voyeuristic point-of-view of their canvases and a tendency to objectify the bodies of working-class men and women.[20] As their self-appointed spokesman, Henri eschewed the protocols of the European academy, and advocated instead for the slap-dash aesthetics of the tabloid reporter. His desire to release American artists from an unhealthy dependence upon European art resonated with the isolationist political rhetoric of Teddy Roosevelt's administration and its tendency to equate cosmopolitanism with Dandyism.[21]

Henri and his followers sought to convert American parochialism from a weakness to a strength. Thus, rather than avoid the American scene and the ugly consequences of industrialization, he encouraged his colleagues (subsequently derided as the "Ash Can School") to render it in all of its unrefined majesty. John

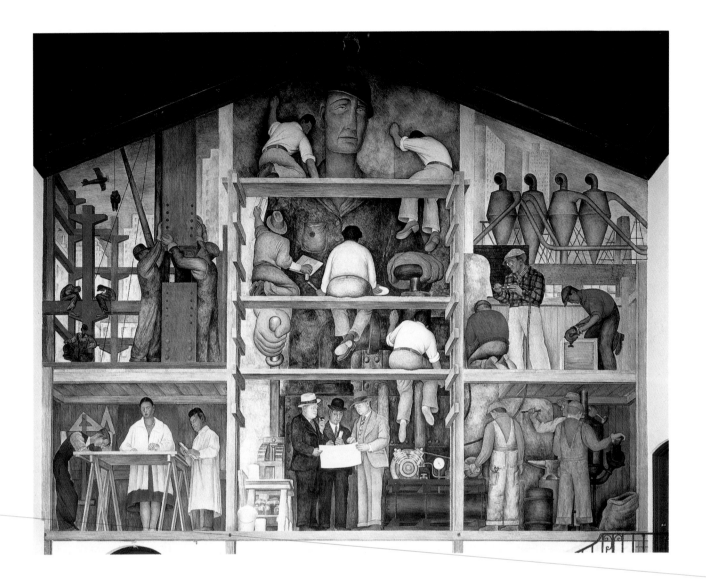

Fig. 39. Diego Rivera, *The Making of a Fresco Showing the Building of a City*, 1931, fresco, 11½ x 29½ ft., San Francisco Art Institute, Gift of William Gerstle.

Sloan's paintings of immigrant and working-class women are a case in point. The odd vantages and intimate views that characterize his oeuvre position the viewer as surreptitious onlooker, given access to the more liberal moral world of working girls in their off-hours.[22] The point here is not to suggest that Sloan or Henri was a pervert or predator, but rather to note the significance of their subject matter and formal strategies for establishing an implicitly masculine profile for the American artist.[23]

Gendering Labor

The preceding discussion traces a subtle but consistent concern among artists within the United States over the gender and status of the native artist. These concerns were only exacerbated by the Great Depression, when, as Barbara Melosh has argued, not only was the masculinity of the artist challenged, but more significantly, that of the ordinary worker. "As men lost their jobs," she writes, "wage-earning women became the targets of public hostility."[24] Gone was the New Woman; in her place New Deal art mobilized a nostalgic iconography of family stability that retooled the feminist desire for independence and per-

sonal freedom into a liberal vision of citizenship predicated on the comradely ideal of compassionate marriage. Not so ironically, this crisis in national manhood ultimately shored up the normative masculinity of the public sphere through essentializing images of what Melosh terms "manly work" and "masculine expertise."[25] The nationwide consistency in style and iconography fostered by the various federal art projects helped to bring the visual arts into the orbit of everyday life in an unprecedented way. Moreover, the routinization of subject matter was an important component in shaping the imagined community of twentieth-century U.S. nationalism. The preponderance of images devoted to masculine labor demarcated from a domestic sphere presided over by strong but decidedly feminine wives helped to assuage national anxieties about the loss of patriarchal competence.[26] While women did participate as artists under state patronage, the subjects they were encouraged to paint undermined advances made during the roaring twenties by promoting a feminine ideal that culminated in 1950s TV moms such as Donna Reed and June Cleaver.

If the mural art disseminated through public art initiatives provided a somewhat anonymous and ubiquitous field of representation, the very public presence of Mexican mural artists working in the United States throughout the 1930s provided specific and highly visible articulations of these themes. Orozco's *Prometheus* was the first mural executed by a Mexican artist in the U.S.; however, the murals that followed by Rivera and Siqueiros were arguably more prominent in the public imagination both then and now.[27] In particular, Rivera's legible style and penchant for provocation probably did more to enhance the public profile of art and the artist within the United States than anyone since Walt Whitman. His flamboyant antics and self-promotion helped to constitute the act of painting as a heroic feat of endurance.[28] The monumental scale of mural art, the very public nature of its execution, and the affinity between its apparatus (scaffolding, day laborers, hammers, chisels, etc.) and the techne of manual labor promoted art in the image of industry.

Perhaps more significant than the mode of manufacture was the rhetorical and iconographic identification of the muralists with the working class. In their famous technical manifesto of 1924, they expressed their solidarity with proletarian and agrarian labor by unionizing, rejecting (in theory) the bourgeois practice of easel painting, and demanding that they be paid according to house painter's scale.[29] Rivera made a pronounced effort to identify the artist with the engineer and construction worker by routinely including self-portraits in his mural cycles in this guise.[30] Within the U. S. context, he made quite an impression on Californians with his 1931 San Francisco Art Institute mural, *The Making of a Fresco, Showing the Building of a City* (fig. 39), wherein he presents an image of himself surrounded by a compendium of manly labor on a trompe l'oeil scaffolding.[31] The point here is clear: Rivera's work as a painter is equivalent to that of the blue-collared proletarian he is monumentalizing in the fresco. That both artist and worker are male only underscores the implicit equation he maintained

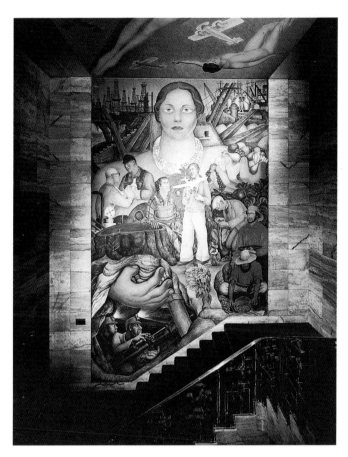

Fig. 40. Diego Rivera, *Allegory of California*, 1931, fresco. Luncheon Club, San Francisco Pacific Stock Exchange.

between art-making, historical agency, and masculinity. When juxtaposed with the other single-wall murals he executed within the U.S.—the 1931 San Francisco Stock Exchange's *Allegory of California* (fig. 40) and 1933 *Man at the Crossroads* (fig. 41), at Rockefeller Center in Manhattan—his tendency to represent the subject of political change in specifically masculine terms becomes clearer. In the former, California's natural resources are allegorized through the figure of tennis star Helen Wills Moody. While she embodies a modern vision of athletic femininity, Moody is presented not as an active tennis champion, but rather as an essentialized icon of an indigenous and sexualized landscape.[32] Conversely, the blond-haired and blue-eyed worker in the destroyed Rockefeller mural presents a utopic vision of human control over the natural world (and by implication, female reproduction, if the vaginal iconography of the Earth's stratification and the images of motherhood and breast-feeding nearby are any indication). Rivera's persistent gendering of nature and culture is not unusual and entirely consistent with the conventional binaries of Western culture.

While Orozco and Rivera differ markedly in their approaches to style, composition, and subject matter, Rivera's U.S. murals must be understood as part of the articulatory system within which the *Prometheus* gleans its retrospective meaning. Like Rivera, Orozco structures his composition around a central iconic figure that is both specific and universal in its allusions. Just as the male workers that anchor Rivera's murals are to be read simultaneously as portraits of the proletariat and symbolic surrogates of human agency in the struggle to revolutionize society, Orozco's icon is both the Prometheus of myth and a more generalized figure of man's existential dilemmas within the eternal recurrence of human history. On the other hand, Orozco's mural is distinct in that its relationship to contemporary events and politics is only obscurely metaphorical. That is, while Rivera's commitment to the socialist cause is writ large in all of his U.S. murals, one can view Orozco's mural and never consider the immediate threat of European fascism or the contemporary ideological struggles over capitalist and communist formulations of democracy. For postwar artists such as Jackson Pollock, this made his work a more viable example of how to approach pressing political concerns about human will and the traumas of history in less didactic and temporally marked terms. Yet, the undeniable masculinity of Orozco's pantheon of existential heroes served to reaffirm the patriarchal tendency in Enlightenment culture to couch the universal in decidedly male terms.

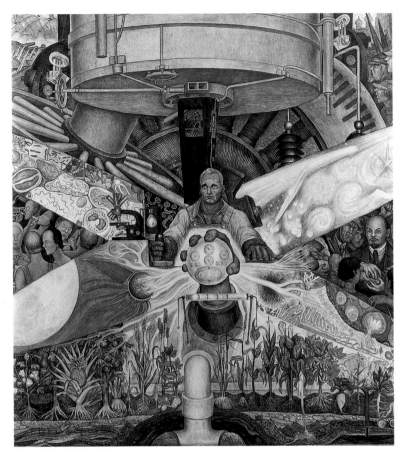

Fig. 41. Diego Rivera, *Man at the Crossroads*, 1933, Palace of Fine Arts, Mexico City.

As Pollock and his peers moved further away from social realism, they sublimated the gender politics of figuration into the creative act itself. When Harold Rosenberg fetishized these artists, dubbing them "Action" painters, he deflected critical attention from their iconography in favor of the procreative act itself. It is no secret that the art world of the '40s and '50s was notoriously macho and almost impenetrable to women artists. Not only was Abstract Expressionism associated with a rugged individualism predicated on the mythical cowboy and a depressive vision of alienated labor, but the vocation of art-making itself had become so thoroughly circumscribed by masculine prerogatives that women felt biologically disadvantaged in wholly new ways. Nowhere is this more apparent than in Hans Hofmann's backhanded compliment to Lee Krasner, that her painting was "so good you would not know it was done by a woman."[33] Recalling this period after a lifetime of critical neglect, Krasner remarks, "at that time I didn't think that my problems had to do with being a woman. Now there is a consciousness about that. I view it on a different level."[34]

It is by now a commonplace to note that Abstract Expressionism took its sense of scale, politics, and many of its experimental techniques from the example of the muralists.[35] The shift from the figurative idioms and radical politics associated with inter-war art to the abstraction and existential ethos of postwar painters marked more than a shift in form and content. It effectively turned a specific iconography of masculine labor into an abstracted form of male privilege. This privilege is masked by a non-representational formal language that naturalizes the socially inscribed gender of the creative subject precisely because it doesn't traffic in a gender-specific iconography.

Coda: Penetrating the Masculine Sphere

In 1961 Pomona College made its first tentative steps toward social integration by establishing coeducational dining on Monday evenings. This prompted a rather comical protest from a group of male students who used the *Prometheus* as a symbolic stage for their objections (fig. 42).[36] A survey of their slogans reveals a disconcerting mixture of hostility and absurdity. For example, one placard states simply, "A Man's Dining Hall is His Castle!" while another makes the bizarre

Fig. 42. Pomona College students protesting establishment of coeducational dining, Frary Dining Hall, 1961. Pomona College Archives, Special Collections, Honnold/Mudd Library, The Claremont Colleges.

assertion, "Bisexual Dining Leads to Bisexual Marriage!" This proprietary rhetoric reveals that not only did these students presume a patriarchal privilege over this public sphere, but that the very presence of women within it threatened to confuse the rigid gender protocols that took hold in the repressive '50s.

These young men's protest provides an apt metaphor for critical attempts, throughout the 1960s, to shore up a hard-won heteronormative and masculine identity for the artist against the ambivalent sexual politics of camp, pop, and neo-dada sensibilities.[37] Ultimately it would take the feminist art movement of the 1970s to expose how sex discrimination structured access and recognition within the art world. The craft-based aesthetics of Judy Chicago's "cunt-art" and Miriam Schapiro's "femage" unmasked the gender asymmetry that authorized the differential valuation of media and the hierarchies of high and low. Similarly, Carolee Schneeman, Lynda Benglis, and Janine Antoni lampooned and exaggerated the performative subjectivity of Abstract Expressionism through visibly and undeniably embodied performances. The feminist penetration of the art world coincided with Pomona College's integration of its north and south campuses through coeducational living.

In conclusion, I want to return to the protesting students of 1961. Rather than write this off as a hysterical response to an inchoate sexual revolution, I would argue that it was a rational consequence of rupturing the seamless continuity between masculinity and the public sphere. The architectural semiotics of the north campus are epitomized by Orozco's mural, and as such it was a fitting platform and excuse for protesting the indecorousness of the exposed male body. Appealing to the maternal propriety of national motherhood, one student's poster asks, "Mothers of America, do you want your daughters looking at Prometheus?"

Melissa Deem has argued that the naturalized link between masculinity, agency, and the public sphere is secured through a logic of abstraction that renders the bourgeois white male body normative, and thus invisible, while making spectacles of those bodies that are marked as different (namely ethnic and racial minorities and women).[38] Thus, she concludes, strategies that render the male body visible are both transgressive and potentially transformative. With this in mind, I want to suggest that what coeducational dining threatened was not necessarily the contamination of a masculine sphere with female desire, but rather the exposure of the male body. Prometheus's nudity was unproblematic within the milieu of an all-male dormitory and refectory because it remained an abstraction. However, his nakedness (and lack of genitalia) becomes visible when the gender of the mural, its audience, and its social sphere are no longer congruent. In mixed company, Prometheus's body becomes a signifier of desire, or more problematically, victimization.[39]

The vulnerability of the male body made visible necessitates the reassertion of male privilege. Thus, the student's appeal to maternal discipline can be interpreted as a prophylactic call to sexual order. It bears note that the gender integration of the dormitories in 1969-70 seems to have inaugurated the vandalism and perennial caricature of Prometheus's genital lack.[40] The first article in *The Student Life* on this topic appears in November of 1972. It recounts the guerrilla antics of an anonymous student group that apparently attached a codpiece to the fresco in order to end a "disgraceful period of Eunuchism" and to defend Prometheus's "blade" against the "watery emissions of the powerless."[41] The relationship between this act and the sexual integration of the dorms is insinuated in the students' published statement, which exclaims, with feigned contrition, "we hope that our modern women found in abundance at such asylums shall not find their new found chastity rudely fingered by our emboldened, fire-emitting gift."[42]

In a 1995 *Student Life* editorial, subtitled "The Time Has Come For Prometheus to Be Delivered from Genderless Shame," the self-proclaimed "penis-owning" author argues that the restoration effort then under way provided an optimum occasion to supplement the mural. Drawing on the tacit connection between sexual potency and artistic creation, he jokes, "the scaffolding has been erected; the bristles of the brushes are stiff with anticipation; the paint is ready to be sprayed."[43] In this innuendo-laden prose, he argues that attention to the "manhood" of *Prometheus* has been "elongated" by its conspicuous absence. "Nobody stands around Michelangelo's *David* talking about his package," he claims, "but if somebody took a chisel to him, they would."[44] Perhaps these attempts to reconstitute *Prometheus's* "manhood" with a host of surrogates demonstrates mere adolescent pranksterism, or perhaps they are anxious stabs at re-membering the abstracted male body in order to reassert the privileges of invisibility. The 1995 *Student Life* caricature of Prometheus clutching at his groin in embarrassed agony suggests that the two are intimately bound.

I would like to thank Marjorie Harth and George Gorse for the many conversations that informed the conception and writing of this essay. I would also like to express my gratitude to Carrie Marsh and Jean Beckner. Their generous help in Honnold Library's Special Collections proved invaluable for navigating the College's archives in an expedient fashion.

1. L. Kent Wolgamott, "Mexican Muralist Had Influence on Pollock's Painting," *Lincoln* (NE) *Journal Star,* February 1999, sec. A, p. 4, cited in http://sheldon.unl.edu (22 February 2000). My attention was brought to this by Karen Cordero Reiman's "Prometheus Unraveled: Readings of and from the Body. Orozco's Pomona College Mural," *José Clemente Orozco in the United States, 1927-1934* (Hanover, New Hampshire: Hood Museum of Art and New York: W. W. Norton & Co., 2002).

2. While Pomona College was founded in 1887, in 1910 it undertook a building project for expansion. The architect Myron Hunt formulated a gendered layout for the campus that located the sciences and men's dormitories to the north and the fine arts and women's dormitories to the south. This essentialized association between gender and discipline was enhanced by architectural styles that reflected similar assumptions about men's and women's spaces. See E. Wilson Lyon, *The History of Pomona College, 1887-1969* (Claremont: The Castle Press, 1977).

3. David Scott relays this in both of his essays in this volume. See page 15, f.n. 10, and p. 31.

4. While there is some confusion on the topic, a consensus about Orozco's intentions vis-à-vis Prometheus's genitals has been reached. Preparatory sketches for the mural are anatomically correct. Moreover, the compositional lines of force all converge upon Prometheus's groin. This suggests that his vitality and sex were conceptually linked. Concerned about the reaction of College officials, some of whom had already expressed reservations about his work, Orozco elected not to execute a penis in true fresco. He did, however, add genitals *a secco* before leaving Claremont. My thanks to Marjorie Harth for making me aware of this controversy and for directing me to archival materials on the subject. Her essay in this volume provides further detail.

5. Scott, "Orozco's *Prometheus*: Summation, Transition, Innovation," *College Art Journal* XVII: 1 (Fall 1957): 6-8 (reprinted in this volume, see p. 13).

6. Articulation has been variously defined by cultural studies theorists. However, in this essay, I am adhering to the basic insights of Stuart Hall and his interlocutors. To wit, Larry Grossberg writes, "articulation is the production of identity on top of differences, of unities out of fragments, of structures across practices. Articulation links this practice to that effect, this text to that meaning, this meaning to that reality, this experience to those politics. And these links are themselves articulated into larger structures, etc." Larry Grossberg, *We Gotta Get Out of This Place: Popular Conservatism and Postmodern Culture* (London, New York: Routledge, 1992), 53. It is important to note that articulation is not necessary, determined, absolute, or essential. Rather it is contingent upon specific conditions. Furthermore, despite its arbitrariness, the unity formed through the complex structures of articulation can be very durable and difficult to destabilize.

7. Amelia Jones, "The 'Pollockian Performative' and the Revision of the Modernist Subject," *Body Art/ Performing the Subject* (Minneapolis, London: University of Minnesota Press, 1998), 53-103.

8. Jackson Pollock was dubbed "Jack the Dripper" in a 1956 *Time* magazine article. The overtones of sexual violence conjured up by this nickname are too ripe to resist comment, given the concerns of this essay.

9. I am extrapolating from a rich literature on the topic. Several authors have discussed the relationship between the development of the artist and cultural anxieties over feminization and more recently, emasculation. See, for example, Andreas Huyssen, *After the Great Divide: Modernism, Mass Culture, Postmodernism* (Bloomington, Indianapolis: Indiana University Press, 1986); Raymond Williams, *The Politics of Modernism: Against the New Conformists*, ed. Tony Pinkney (London, New York: Verso, 1989); Alan Trachtenberg, *The Incorporation of America: Culture and Society in the Gilded Age* (Toronto, New York: Hill and Wang, 1982); Dana D. Nelson, *National Manhood: Capitalist Citizenship and the Imagined Fraternity of White Men* (Durham, London: Duke University Press, 1998); and Kirk Savage, *Standing Soldiers, Kneeling Slaves: Race, War, and Monument in Nineteenth-Century America* (New Jersey: Princeton University Press, 1997).

10. Randall C. Griffin, "Thomas Eakins' Construction of the Male Body, or 'Men Get to Know Each Other Across the Space of Time'," *The Oxford Art Journal* 18, 2 (1995): 70.

11. *Ibid.*

12. The Athenaeum of Youth, founded in 1909, was an organization of students united by a rejection of the positivist social philosophy that characterized the political culture of Porfirio Diaz's dictatorship (1884-1911). These young intellectuals embraced the humanist philosophies of fin-de-siècle Europe and advocated artistic freedom over direct involvement in politics. Nonetheless, many of its members were enfranchised by the post-revolutionary government as chief policy makers and departmental heads, the most prominent being José Vasconcelos, who was appointed by President

Obregon to head up the New Ministry of Public Education in 1921. Vasconcelos inaugurated the mural project as part of his public education initiative, and his influence, particularly his advocacy of pythagoreanism, is evident throughout Orozco's oeuvre.

The Delphic Circle was an ashram established by Eva Sikelianos and Alma Reed (Orozco's primary supporters and benefactors during his stay in the United States from 1928-32). The Delphic program was heavily influenced by Nietzsche and Spanish philosopher José Ortega y Gassett. Like the Athenaeum of Youth, its members sought the development of a cultural elite that would enable social justice and enlighten the masses. Orozco's involvement with Sikelianos and Reed only deepened an already extant belief in the power of Greek culture to revitalize a decadent Western civilization. For a more detailed discussion of the influence of these figures on the development of Orozco's career, particularly during his stay in the United States. See Alejandro Anreus, *Orozco in Gringoland: The New York Years* (Albuquerque: University of New Mexico Press, 2001).

13. The following examples illustrate this tendency. Orozco's first mural at the National Preparatory School depicts a benign, blond Madonna as an icon of "Maternity." However, when he changed the content and style of these frescoes from neo-classical allegory to the satirical caricatures of the recent Revolution, women became either portraits of mourning campesinas or bloated figures of the corrupt rich. In his Dartmouth murals (1932), a female school teacher represents the bloodless automation of Protestant culture. In *Catharsis* (1934) at the Palace of Fine Arts in Mexico City, the grotesque faces and bodies of syphilitic prostitutes emblematize the corruption of a civilization on the brink of technological catastrophe. In the *Allegory of Mexico* (1940) in Michoacán, Mexico's history of civil strife is represented by the deadly conflict between a serpent, eagle, and jaguar, while a rebozo-clad woman rides another jaguar through cacti. She is meant to recall the Whore of Babylon and thus to equate Mexican nationalism with Biblical Apocalypse.

14. Quoted in Barbara Rose, *American Art Since 1900* (Chicago: Holt, Rinehart and Winston, Inc., 1975), 30.

15. Stieglitz quoted in Dorothy Norman, *Alfred Stieglitz: An American Seer* (New York: Random House, 1973), 44.

16. The classic essay on the political implications of the loss of aura occasioned by the camera, film, and print technologies is, of course, Walter Benjamin's "The Work of Art in the Age of Mechanical Reproduction," *Illuminations*, trans. Harry Zohn, ed. Hannah Arendt (New York: Schocken Books, 1969), 217-251. For more historicized discussions of the effects of capitalism and industry on humanist conceptions of agency, authorship and white masculinity, see Trachtenberg 1982, Nelson 1998, and Savage 1997.

17. Stieglitz in Norman, *Alfred Stieglitz: An American Seer*, 42.

18. Robert Henri, "The New York Exhibition of Independent Artists, 1910", reprinted in John McCoubrey, *American Art, 1700-1960: Sources and Documents* (New Jersey: Prentice-Hall, Inc., 1965), 174.

19. In his collected lectures and essays, he repeatedly addresses his students as "men," "sons," and a "brotherhood." For example, in one motivational passage, he exclaims, "do some great work, Son!" and then invokes Courbet, explaining that he "showed in every work what a man he was." Robert Henri, *The Art Spirit*, compiled by Margery Ryerson (Philadelphia, New York: J. B. Lippincott Company, 1923), 8. In her class notes, Margery Ryerson transcribes Henri's definition of the artist as "a man who leaves the crowd and goes pioneering." *Ibid.*, 271.

20. For a discussion of the objectification of male privilege and mobility in Impressionist painting and the limitations this imposed upon women within the changing sexual dynamics of social space in 19th century France, see Griselda Pollock, "Modernity and the Spaces of Femininity," *Vision and Difference: Femininity, Feminism, and Histories of Art* (London, New York: Routledge, 1988), 50-91.

21. For an insightful analysis of the relationship between masculinity, nationhood, and Roosevelt's persona see Donna Haraway, "Teddy Bear Patriarchy: Taxidermy in the Garden of Eden, New York City, 1908-1936," *Social Text* 11 (1984): 20-64.

22. Patricia Hills has discussed Sloan's paintings of working-class girls in great detail. Quoting from the artist's published teaching notes, where he recalls his enthusiasm for "unspoiled girlhood" and the "unconscious grace" of a woman hanging wash, she argues that through these subjects, Sloan was giving visual form to his socialist politics and the related "desire for purification, redemption, and regeneration in a world *here and now* (her emphasis)." Hills, "John Sloan's Images of Working-Class Women: A Case Study of the Roles and Interrelationships of Politics, Personality, and Patrons in the Development of Sloan's Art, 1905-16," *Prospects* 5 (1981): 176-77.

23. Here I am referring to Laura Mulvey's seminal essay on the filmic constitution of the male gaze in *Visual and Other Pleasures* (Bloomington: Indiana University Press, 1989). While the Ash Can School predates Mulvey's analysis, their work offers suggestive possibilities in light of her argument, especially given the cross-fertilization between artists and Nickelodeons during this period.

24. Barbara Melosh, "Introduction," *Engendering Culture: Manhood and Womanhood in New Deal Public Art and Theater* (Washington, London: Smithsonian Institution Press, 1991), 1.

25. There were several different federal art projects under the New Deal: The Public Works of Art Project/PWAP (1933-34); Works Progress Administration/Federal Art Project/WPA/FAP (1935-43); Treasury Art Relief Project/TRAP (1935-49); and the Treasury Department's Section of Painting and Sculpture (Section of Fine Arts)/"The Section" (1934-43). There are important distinctions between each project in terms of the direct influence of federal patrons, the input of local publics, and the standardization of iconography; but, for the purposes of this essay, I am generalizing about them.

26. Melosh, *Engendering Culture*.

27. While I won't be discussing it, Siqueiros's Olvera Street Mural remains legendary on the West Coast, especially within the Chicano community. Unlike his compatriots, Siqueiros was the only Mexican to make an explicit statement about the plight of Mexican-Americans in the United States. He and Rivera argued publicly over the appropriate content for mural art within the United States in a very nasty polemic carried out within the pages of communist journals and ultimately in Mexico City in 1934. For a contemporary account, see Emanuel Eisenberg, "Battle of the Century," *New Masses*, 10 December 1935, p. 18.

28. The press coverage of Rivera stressed his physical prowess and the physical demands of monumental fresco painting. Furthermore, the artist often suffered physical collapse after working on a major commission due to overextending himself or poor diet.

29. The first manifesto of the Syndicate of Technical Workers, Painters, and Sculptors was published in the seventh issue of the union newspaper *El Machete* in 1924. It has since been reproduced in English in Dawn Ades, *Art in Latin America: The Modern Era*, 1820-1980 (New Haven, London: Yale University Press, 1989), 323-4.

30. At the top of the stairwell of the Ministry of Public Education, Rivera painted a self-portrait in worker's overalls amid engineers and plasterers.

31. Rivera was always mindful of scattering an image or two of professional women within his murals, however, their relative scarcity demonstrates that they are really only exceptions that prove the rule. In some commissions, it is clear he struggled with the gap between his vision of gender equity and the reality that "social realism" dictated he address. See, for example, the *Detroit Industry* murals where women workers are represented in carefully delineated and segregated spheres of labor that correspond to the specific jobs allocated to them within Ford's factory.

32. In a nationalist touch, Rivera renders her necklace in a pre-Columbian design motif that is specific to Meso-American, not Native North American cultures. She enfolds in her arms an agricultural cornucopia through which her breasts are analogized with rounded fruit. Furthermore, male miners penetrate the surface of her body with an enormous, phallic drill. Rounding out this overtly sexual and gendered iconography is a young boy who holds a model airplane in his hands. He symbolizes the promise of youth and a human agency that draws power from natural resources.

33. Krasner recalls this in an interview with Cindy Nemser in *Art Talk: Conversations with 15 Women Artists* (New York: Harper Collins, 1975), 73.

34. *Ibid.*, 75. Krasner's willingness to acknowledge the sexism of the art world is relatively unique among her female peers. Most of the women who experienced modest success as "second generation" Abstract Expressionists are loath to admit that they were ever subject to gender discrimination. A forum for women artists that Cindy Nemser organized in 1970 illustrates this distinction. When Nemser asked, "As a female artist have you ever experienced discrimination from the art world?" Grace Hartigan defensively stated, "I find that the subject of discrimination is only brought up by inferior talents to excuse their own inadequacy as artists." To this Krasner replied, "Any woman artist who says there is no discrimination against women in the art world should have her face slapped." The routine invocation of "quality" and "excellence" as the best weapons against sexism among the participants in the forum reveals the extent to which women artists internalized the discourse of gender inadequacy. Within this logic, it is not the exclusive structures of the art world that relegate the work of women to obscurity, but rather their lack of real talent. This exchange is published in Nemser, *Art Talk*, 9-11.

35. Shifra Goldman pioneered this corrective historiography. Ellen Landau provides the most detailed discussion of the relationship between Pollock and the Mexicans in her book, *Jackson Pollock* (New York: Abrams, 1989).

36. Prior to coeducational living, women could eat at Frary with the invitation and escort of a male student. This explains the presence of two female students in the photograph. The exact date of this protest is difficult to pin down. The slogans, context clues, and clothing appear to correspond with the integration of the dining halls and not the dormitories (which occurred in 1969-70). It is unclear how many of the dining halls were integrated and whether this occurred in the late '50s or early '60s. Nonetheless, in the 1961 year-book, the caption for another photograph taken of Frary Hall

indicates that the Monday night coed dining was a "first attempt at social integration" on the campus. From this evidence, I've deduced that the photograph must come from 1961 or thereabouts. Furthermore, without any supporting evidence, it is difficult to tell just how widespread the sentiments expressed in the placards were, or, for that matter, whether or not the protest was in jest or very serious. While some of the slogans seem too silly to be sincere, the hostility of others, such as "Halloween is Over, Go Home," and "Women, Go Home!" resist an ironic read. I would argue that it matters little if this was an isolated incident or a practical joke. The slogans are being examined here for the light they shed on how Orozco's mural helped to naturalize the gender-exclusivity of the dining hall.

37. Amelia Jones makes an interesting and convincing argument that the development of Greenbergian formalism and its tendency to abstract the subject of painting was an attempt to shore up heterosexual and masculine privilege at the very moment that artists like Rauschenberg, Johns, and Warhol were cultivating kitsch and camp in response to the hyper-masculinity of Abstract Expressionism. Furthermore, she suggests that the development of postmodern art and theory, which took the claims of Greenbergian formalism as its primary target, resuscitated the persona of Duchamp precisely because he provided a feminized genealogy for the post-war artist that could challenge Greenberg's modernism from within. Jones, "The Pollockian Performative," 53-102.

38. Melissa Deem, "From Bobbitt to SCUM: Re-memberment, Scatological Rhetorics, and Feminist Strategies in the Contemporary United States," *Public Culture* 8 (1996): 512.

39. Deem argues that speech in the public sphere is regulated by the rules of decorum, which are in turn dependent upon an abstracted body. For this reason, women's speech about gender violence and sexual discrimination is deemed indecorous and routinely relegated to the category of the "complaint." Since arguments predicated upon marked bodily difference rupture the abstracted logic of decorum, feminist arguments are always already positioned within the rhetorics of complaint. This is a "cramped space" with very little political effectiveness. In her analysis of the popular discourse generated by Valerie Solanas's SCUM Manifesto and Lorena Bobbitt's castration of her husband, Deem argues that the specter of violence against the male body makes that body visible and vulnerable, and thus places men within the rhetoric of complaint that characterizes women's speech. It is for this reason that she argues that a transformative politics might follow from discourses that make the male body visible and vulnerable. It is important to note that Deem does not advocate the castration of men, rather, she argues for a form of feminist rhetorical analysis sensitive to the politics of the body that authorize decorum. To that end, she reads Solanas's manifesto as a politicized violation of the rules of decorum, not as a literal call to arms. Deem, "From Bobbitt to SCUM," 511-537.

40. Prior to 1972, I could find no editorials or articles about vandalism or Prometheus's lack of genitalia. Earlier essays either celebrate the mural or defend it from aesthetic criticism. There is only one, ambiguous reference to "incomplete" passages in the mural, but it doesn't specify his penis, nor does it make any subtle insinuations about this. See Marjorie Harth's essay for additional detail.

41. "Prometheus Unbound, Myth Revealed," *The Student Life*, 7 November 1972, p. 4.

42. *Ibid.*

43. Mike Boyle, "And on the Sixth Day God Created Man: The Time Has Come for Prometheus to be Delivered from Genderless Shame," *The Student Life*, 21 April 1995, p. 10.

44. *Ibid.*

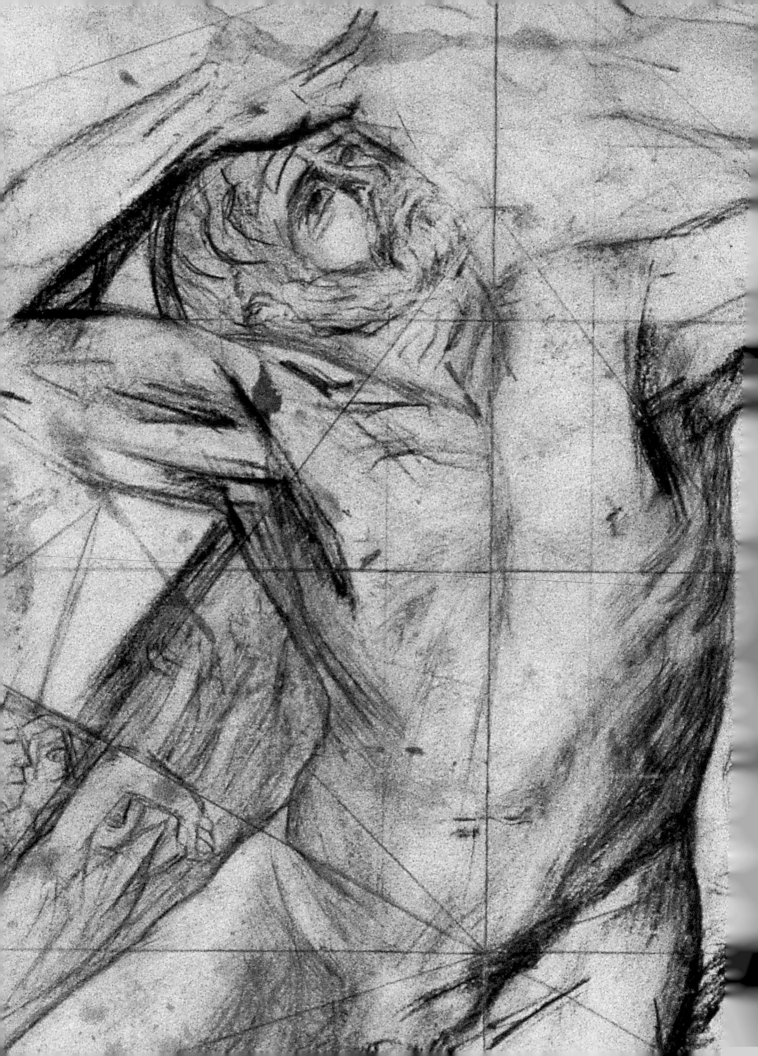

Since 1930: Living with *Prometheus*

by Marjorie L. Harth

I N SOME RESPECTS, the history of José Clemente Orozco's mural since its completion mirrors that of its mythical subject. Prometheus's heroic effort to bring the fire of knowledge to humankind was met with mixed response by its human beneficiaries, as Orozco clearly shows, and punished in grisly fashion by the gods. As Hesiod related the legend, a vengeful Zeus had Prometheus chained to a rock where, by day, an eagle pecked out his liver and, by night, the organ healed itself, only to be attacked anew in an unending cycle of hope and despair. The life of Pomona College's *Prometheus*, though less dramatically violent, might be said to have followed a similar course. Since its completion in June of 1930, the mural has been both lauded and disdained, and has survived considerable adversity, if not outright torture. The preceding essays offer a richly detailed and nuanced portrait of Orozco's mural. It is my intention here to amplify the story they tell with some curatorial reflections on the life of (and life with) this extraordinary work of art.

Marcel Duchamp held that when a work of art is completed, it dies. The relic of a process, the art object can live on as an effective presence only by virtue of the response it engenders. Once the artist's work is done, he implies, the viewer is responsible, in a philosophical sense, for the object's very existence. The responsibility of museum professionals is, of course, practical as well. We think a great deal about the nature and extent of our accountability for the works of art entrusted to our care and also, inevitably, about the vulnerability of our charges. But, whereas physical fragility is commonly assumed and addressed, the degree to which art objects are, as Duchamp suggested, dependent upon public response and interpretation is less frequently acknowledged and, often, even more difficult to accommodate. Since 1930 Orozco's *Prometheus* has been the object of considerable attention in both realms.

Orozco's mural falls within the curatorial jurisdiction of the Pomona College Museum of Art (formerly Montgomery Gallery[1]), which, like all museums, is responsible for preserving and exhibiting its collections and educating its public

Fig. 43. José Clemente Orozco, Study for central panel, *Prometheus* mural, 1930, graphite on paper, 17 5/8 x 23 3/8 in., detail, Pomona College, Claremont, California.

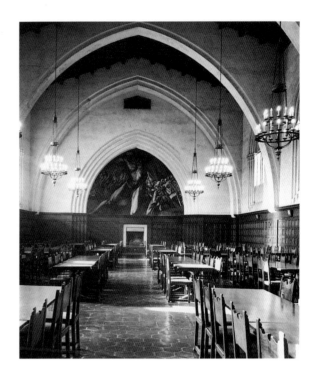

Fig. 44. Frary Refectory before *Prometheus*, showing tapestry used for niche decoration, 1929–30. Pomona College Archives.

Fig. 45. Frary Refectory after the painting of *Prometheus*, 1930. Pomona College Archives.

about them. What this means in practical terms, however, is significantly more challenging in the case of the architectural, site-specific work of art than for the object maintained within the museum. Wedded to its circumstances, the public mural is dependent upon its environment in a way that portable art is not. Unlike the easel painting that hangs quietly on the museum wall awaiting the responsive viewer who will return it to life, that can be removed from public view when conservation is required, or tactfully retired to storage when shifts in aesthetic fashion so dictate, the public mural is insistently present, come what may.

It is the rare work of art in a public place that does not suffer in some way from its environment, if not also from its public, and, as with other public murals in heavily used, non-art spaces, the very familiarity of *Prometheus* works against the notion of extraordinary value. The subject of Orozco's mural, its location in a dining hall, and the nature of its primary audience all contribute to the challenge of preservation. It is impossible in Frary Hall to provide ideal levels of security and climate control or to create the aura of sanctity that helps protect works of art in museums and determines the way they are perceived. This is, of course, as it should be—Orozco's mural was intended by the artist to be part of Pomona students' daily lives—but it is also problematic, to say the least, from a curatorial point of view. The students who frequent Frary Hall have not chosen to be there for purposes of education or aesthetic contemplation and have no control over the Promethean presence that oversees their meals. And the fact that the mural features a nude figure whose genitals were minimized by the artist for fear of disapproval makes it particularly vulnerable to an audience comprised primarily of late adolescents for whom sexuality is a prominent issue. Taken together, these inescapable facts both intensify the importance of education and preservation (which are, in fact, inextricably intertwined) and greatly complicate the process.

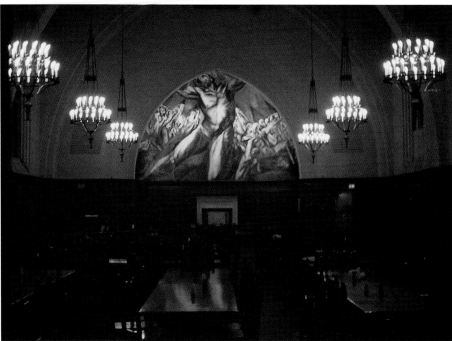

Fig. 46. Frary Hall, 1980s.
Pomona College Archives.

Fig. 47. *Prometheus* after
completion of conservation
work, 1983. Orozco Archives.
Pomona College Museum of Art.

Ironically, the fact that *Prometheus* cannot be moved also makes it less vulnerable than the easel painting, at least in one respect. I refer here to the current museum fashion of reinstalling permanent collections in thematic groupings accompanied by extensive explanatory texts. Breaking with the long tradition of the chronology-based "hang," with its lockstep progression of artistic styles and movements through time, this contextualizing trend reflects the interpretive richness of contemporary academic scholarship while also implying that works of art need curatorial intervention in order to communicate. Whether one agrees, or maintains the inviolable capacity of the art object to speak for itself, the extent to which works of art are vulnerable to context and presentation is undeniable. The architectural mural is resistant to this kind of manipulation—its location, site, and scale all help to protect the artist's voice, to make the work less vulnerable to reinterpretation. Assuming, that is, that it is preserved.

Preservation and Education

In theory, the core responsibilities of the museum of art—collection, preservation, exhibition, interpretation—are of equal value, and the task of the institution is to maintain a reasonable balance among them. In practice, however, a case can be made for the primacy of preservation. There is a terrible finality to the loss of a unique object of value, however well documented it may be. And if it is true, as I believe, that what distinguishes museums from other public educational institutions is the fact that they contain unique objects—what Dillon Ripley called "the raw data of culture"—then it stands to reason that preserving those objects is nothing less than a sacred trust. I would also argue that although all museums "educate," the pedagogical mission of the academic museum—one educational institution within another—is both doubly vital and doubly complex. There is a

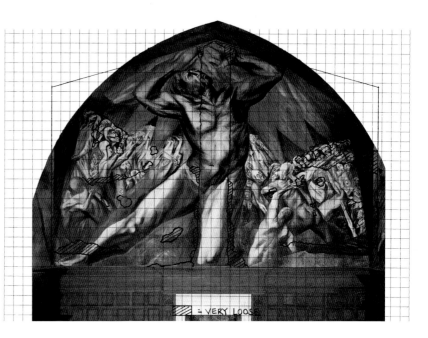

= VERY LOOSE

Fig. 48. Art students cleaning surface of mural with bread. Photo: *Los Angeles Times*, May 25, 1956.

Fig. 49. Conservator Nathan Zakheim's diagram indicating location of vertical cracks and unstable areas of mural. Orozco Archives, Pomona College Museum of Art.

necessary self-consciousness about what we do, a need not only to research and interpret the works of art in our care but also to make certain students understand why this is important.

When I arrived in Claremont in 1981 as director of what was then the joint galleries program of Pomona and Scripps colleges,[2] efforts to attend to *Prometheus*, which badly needed cleaning and repair, were just getting under way. David Rubin, acting director in 1980-81, had convinced the College administration of the need for conservation, a modest budget had been allocated, and mural conservator Nathan Zakheim had been identified. This was not the first time Orozco's fresco had needed attention. In May 1956, both the *Los Angeles Times* and the *Pomona Progress Bulletin* featured articles on Pomona students who, under the direction of Professor of Art James Grant, had spent a day cleaning the surface of the mural with soft white bread, which works much like an art gum eraser. One photograph shows several students, including Richard Chamberlain '56 and Mowry Baden '58, perched on scaffolding and on the narrow wainscoting beneath the mural, loaves of Wonder bread in hand (fig. 48). The first time the mural was treated by a professional conservator was in 1971 when Ben Johnson, founder and director of the conservation laboratory at the Los Angeles County Museum of Art, was hired to repair damage caused by a roof leak and to reattach several areas of flaking paint. Johnson also removed an acrylic penis that had been added by students, apparently responding to an entrenched myth that the genitals with which Orozco had originally endowed the figure of Prometheus had been censored by the College and painted out.[3] Despite ample scientific and documentary evidence to the contrary, this story persisted, resulting over the next ten years in periodic defacement that members of the Art Department did their best to repair and disguise.[4] By 1981 it was apparent that professional attention was, once again, necessary.

Conservator Zakheim's first proposal suggested that an area of discoloration in the upper part of the mural had probably been caused by water entering the

Fig. 50. Conservator Nathan Zakheim's drawing of chimney interior showing location of bricks. Orozco Archives, Pomona College Museum of Art.

Fig. 51. Interior view of chimney, 1983. Orozco Archives, Pomona College Museum of Art.

flues on either side of the chimney and then migrating to the fresco wall. Two prominent vertical cracks running through the figure of Prometheus were, he believed, the result of the building's settling (fig. 49). In a report to President David Alexander dated February 5, 1982, however, Zakheim reported the astonishing news that, while carrying out surface cleaning and repair, he had discovered that both problems appeared to be the result of the construction of the chimney behind the mural. Rather than being composed of poured concrete on all sides as shown in the blueprints of Frary Hall, the chimney's front wall consisted, in fact, of a free-standing column of mortared bricks, 13 inches thick by 3 feet across, located on the same plane as the back of the mural. The long cracks visible on the surface of the painting were found to correspond to the sides of the chimney, which, it was now understood, had also provided access for water from above (fig. 50). In short, the center of the main panel containing the figure of Prometheus was seriously unstable and in danger of detaching itself from the wall. One could only imagine the disastrous effect of an earthquake, a not uncommon phenomenon in this region; even a mild tremor could dislodge the fragile surface. In consultation with a team of structural engineers, Zakheim devised an ingenious and ultimately successful solution, and it is to their credit and that of the College, which was faced with a budget considerably larger than originally submitted, that *Prometheus* escaped destruction.

Zakheim's original contract had called for cleaning, the removal of various later additions and repairs, and consolidation of the mural's surface. The chimney problem, discovered as this work was nearing completion, meant that rather than unveiling a newly cleaned mural, another, far more urgent conservation initiative would have to be undertaken. This second phase, which began one year later, was complex and multifaceted. Its major stages included facing the front of the mural with rice paper and muslin and then constructing plywood bracing to hold it securely in place (fig. 52); cutting a portal into the exterior of the north wall of the building to provide access to the interior of the chimney; removing

Fig. 52. Front of mural with bracing, preliminary to work in chimney. Orozco Archives, Pomona College Museum of Art.

the column of bricks inside the chimney and exposing the back of the mural; and bracing the exposed section and covering it with metal mesh that was attached to the concrete wall on either side and layered with epoxy, thus creating a stable backing. This sounds more straightforward than it was. *Prometheus* presented so unusual—indeed unique—a conservation challenge that solutions had to be invented to resolve the unanticipated problems that inevitably arose. For example, in order to work inside the narrow (18 x 27 in.) space of the chimney, Zakheim devised a rope and pulley system that enabled him to raise and lower a suspended platform from which he could work (fig. 51). The unstable bricks were painstakingly removed by hand and hauled overhead in a basket. For all the sophisticated scientific and engineering expertise brought to bear on the situation, the operation looked oddly medieval. The same could be said for the schedule, which stretched on well beyond even the most conservative projections. Finally, in late spring 1983, work on the chimney was complete and the mural's surface could be revealed. It remained only to fill and inpaint the telltale vertical cracks and to protect the surface with a water-resistant acrylic varnish (figs. 53–54). Nearly two years after work began, *Prometheus* was unveiled. With newly installed track lighting fixtures, it was—and is today—resplendent.

Zakheim's work on *Prometheus* was by far the most extensive ever undertaken, but it was not, alas, to be the last. In 1995, a small area of paint loss was noted; when examined closely, now by a new conservator, Aneta Zebala, other problems were discovered that appeared again to indicate vandalism. Although it seemed clear that the new damage, like the old, was the result of renewed sophomoric pranks involving the Titan's still-debated masculinity rather than calculated vandalism, the effect on the fresco was no less serious.

The curatorial challenge of balancing preservation with education is nowhere more apparent than in the case of a public mural. Lacking the means to protect *Prometheus* without sacrificing its integrity and the public's experience of it, our only recourse was to intensify educational efforts. This time, conservation

Fig. 53. Completing work on the mural surface, 1983. Orozco Archives, Pomona College Museum of Art.

Fig. 54. Filling cracks on surface of mural, 1983. Orozco Archives, Pomona College Museum of Art.

work was deliberately scheduled during classes, when students would be using the dining hall. Unlike the previous campaign, which had required the surface of the mural to be covered, this one permitted work to proceed in full view. Notices on every table explained what was transpiring and why, gave a brief history of the mural and its importance, and invited students to talk with the conservator as she worked. Many did. A letter to all Pomona students co-authored by Associate Dean Ray Buriel, student body president Casey Trupin, and myself reiterated the importance of the mural and our responsibility to protect and preserve it. Articles written by students in the weekly campus newspaper, *The Student Life*, pointed out that Pomona students had played an important role in the early history of the mural, greeting Orozco when he arrived in Claremont, raising funds for his fee, and offering assistance while he painted. The same point is made in a modest color brochure about *Prometheus* that was printed in large numbers and is always available on the tables of Frary Hall. Finally, the lights that illuminate the mural have been upgraded and put on a timer set for meal times, and Aneta Zebala, who has also carried out extensive conservation work on Rico Lebrun's *Genesis* mural in the building's portico, continues to be on call for emergencies. To date, there has been only one isolated incident.

This combination—providing detailed information about *Prometheus* and demonstrating its importance through the care and attention it receives—appears to have been effective. That said, however, we are under no illusions about the vulnerability of this great work of art. Because it will never enjoy the degree of curatorial oversight and control that the museum environment provides, and because its primary public—the Pomona student body—is constantly changing, *Prometheus* will always require special vigilance, proactive educational efforts, and a commitment to ongoing research. Although the vandalism visited upon the mural over the years has had tragic consequences, it is part of the history of the work and, as such, needs to be understood as well as prevented. Several scholars, including Mary Coffey, in this volume, and Karen Cordero Reiman, in her essay

for the forthcoming catalogue of Dartmouth's exhibition, have addressed the significance of ongoing student interest in the Promethean genitalia manifested in satirical articles as well as in periodic attempts to complete the Promethean anatomy. These episodes, they remind us, are part of the history of the mural and significant indicators of student engagement with *Prometheus*. Cordero Reiman writes: "In the end, this carnivalesque battle between students and authorities (or the Titans and the Gods, one might say) belongs, too, to the history of *Prometheus* and its legacy, confirming the vitality and continued pertinence of Orozco's mural to the life of the college community which shares its abode."[5]

The Drawings for *Prometheus*

In 2000, Pomona College acquired seventeen preparatory drawings for *Prometheus* owned by the artist's family. Like the long history of efforts to preserve Orozco's mural, the quest for the drawings has been extended and convoluted, proceeding in fits and starts over a period of nearly fifty years. To my knowledge, the first overture was made by Tirsa (Mrs. David) Scott in a letter to the artist's widow, Margarita Orozco, in 1956.[6] The next record of correspondence is a letter to Mrs. Scott dated November 1962 from Clemente Orozco, the artist's oldest son, introducing again the question of the drawings. This contact was apparently prompted by the publication that year of an English translation of the artist's autobiography in which several of the *Prometheus* drawings were reproduced.[7] In the letter, Clemente offers his assistance in negotiating the purchase of the drawings, which, he writes, his family agrees should be in Claremont. For this reason, he goes on to say, they are prepared to make a "price consideration." Although the records do not indicate why this particular proposal came to naught, it introduces a scenario that would be repeated periodically for nearly forty years. At its core was a dilemma common to the commerce of art, namely, the relationship of value to price.

It is "correct" in art historical circles to maintain that aesthetic value cannot be quantified and that the price paid for a work of art is merely, as critic Robert Hughes once wrote, "an index of desire." Nonetheless, the notion that a high price means high quality is firmly embedded in our culture. The pricing of works of art can also be highly emotional, particularly when family and national pride are at stake, as is the case with the Orozco drawings. However sincerely Orozco's heirs have believed the *Prometheus* drawings belonged at Pomona College, they—and particularly Clemente who has taken the lead in managing his father's collection and protecting his reputation—have, quite understandably, had a difficult time negotiating their sale.

I learned of the existence of the drawings shortly after arriving in Claremont and first discussed the possibility of acquisition with Clemente in 1984, at the time of an exhibition of his father's easel paintings on campus in Bridges Auditorium. It was clear that, as preparatory works, they belonged with the mural and that scholarship would be best served if they were in public hands

and accessible, particularly since the few known *Prometheus* drawings not owned by the family were in private collections.[8] Interest and determination notwithstanding, however, our limited acquisition funds, in combination with Clemente's expectations, led to a cordial impasse that persisted for many years despite periodic efforts to reopen the discussion. In 1990, we were able to negotiate a one-year loan of the drawings, which were shown in Montgomery Gallery in 1991. The exhibition was timed to coincide with the Los Angeles County Museum of Art's major show, "Mexico: Splendors of Thirty Centuries," which intensified interest in Mexican art in the area and contributed to the extraordinary public reception the *Prometheus* drawings received. During the show, Latin American art dealer Mary-Anne Martin, in Claremont to deliver a lecture, provided an appraisal, and once again, there was discussion of purchase. Some years earlier, the gift to the College of the estate of Walter and Elise Mosher had enabled us to establish an acquisition endowment fund. Although the endowment had grown significantly, it was still not sufficient, and the drawings were returned to Mexico.

Ironically, the course of events that ultimately led to Pomona's acquisition of the drawings began with the conviction that we were unlikely ever to reach an agreement with the family and the decision to move forward, instead, with another major purchase: Goya's *La Tauromaquia*. As the College already owned first edition sets of *Los Caprichos, Los Desastres de la Guerra,* and *Los Proverbios,* all donated in 1974 by Norton Simon, the appeal of acquiring the fourth of the artist's major etching series was considerable. Before finalizing this purchase, I wrote again to Clemente, explaining that we were about to commit funds elsewhere. Receiving no response, we purchased *La Tauromaquia* late in 1998. In February 1999, a faxed letter from Orozco's other two children Lucrecia and Alfredo expressed interest in selling the drawings and named a price that, for the first time, was reasonable, if still too high for what remained of our acquisition funds. A counter-offer was made, summarily rejected, and then, a full year later, unexpectedly accepted by all three of the artist's heirs. Nearly seventy years after they were created in Claremont, the drawings, it appeared, were on their way back.

Having agreed to a price, however, we now faced the hurdle of Mexican laws strictly prohibiting the export of works by its most important artists, including José Clemente Orozco. Another long, complicated saga unfolded, and it ultimately took the combined efforts of the Orozco family and a number of intermediaries working on behalf of the College over a six-month period to secure an export permit. Finally, in September 2000, my colleague Elizabeth Villa and I traveled to Mexico City, met with officials, received the drawings from family members, and carried them home. Overnight, the details that had occupied us for months—permits, customs brokers, receipts, payments—faded into insignificance, becoming, like so much of the history of Orozco's *Prometheus*, the stuff of myth. At last, attention could be focused on the drawings themselves.

The Pomona drawings include five compositional and twelve figure studies.

Fig. 55. José Clemente Orozco, Study for ceiling panel (*Abstract Composition* or *Godhead*), *Prometheus* mural, 1930, graphite on paper, 6³/₈ x 28 in., Pomona College, Claremont, California (P2000.2.2).

They offer clear evidence of Orozco's academic training and of the central role of the figure—particularly the heroic male nude—in the classical tradition. At the same time, the drawings give us a wonderfully intimate sense of the artist's hand and process that significantly affects and enhances the way we see and understand the mural. These are clearly working sketches—one of the compositional drawings has a penciled shopping list on the verso, and several are spotted with paint, evidence that Orozco kept them close at hand while he worked—and the correlation between drawings and mural is close. Even the most minimal studies of figures and outstretched arms can be located easily in the finished work, and the more carefully worked compositional drawings are equally related in conception, with two notable exceptions: Orozco's omission in the mural of the genitals indicated in the drawing, as noted above, and a significant change in the conception of the west panel. The drawing for the composition containing Zeus, Hera, and Io shows a schematic cityscape in the lower right of the panel. In the mural, however, this has been reduced to abstraction, the undifferentiated ground bisected by a jagged black form (figs. 57–58). The change is visually and conceptually significant. In her Dartmouth essay, Karen Cordero Reiman links the skyscraper image to Orozco's New York paintings of the 1920s and to a 1929 article in which he "posited the skyscraper as a paradigm for a new configuration of the visual arts, which he predicted would find its culminating expression in muralism." She continues: "The replacement of this paradigmatic artifact, alluding directly to technology's role in the establishment of a new aesthetic order, with an abstract…form traversed by a bayonet-like gesture…confirms Orozco's movement toward a more symbolic visual rhetoric rather than a literal, mimetic vocabulary."[9] It is precisely the kind of scholarly analysis found here, and in

Renato González Mello's essay,[10] that the juxtaposition of the drawings with the mural will, we hope, continue to encourage. Whatever the extent and direction of scholarship to come, however, there is no question that the presence of the drawings on the Pomona College campus represents a significant step in fulfilling our mission to preserve this great work of art, educate our public about it, and pass it on, in enhanced form, to those who follow.

Epilogue

The implication of a monographic study is that it represents a comprehensive summing up of what is known about its subject—that it "settles" the matter, at least for the near future. In truth, this is rarely the case, particularly when, as here, the subject is a great and complex work of art.

The nature of Orozco's *Prometheus*—its form, content, scale, location, audience—as well as the innovative richness of art historical scholarship and increasing interest in the United States in the art of Latin America, makes the study of the mural a complex work in progress. This is particularly true in the case of (and because of) the recently acquired preparatory drawings, most of which are published here for the first time. We have only begun to study these works closely and to understand what they can teach us about Orozco and his art.

The variety of ways in which the scholars represented in this volume take on their subject reflects both the significance of the *Prometheus* and its potential as the focus of future research. Indeed, the preceding essays introduce as many promising new areas of inquiry as they address and resolve old ones. This book makes no pretense to being exhaustive. It is merely the first chapter.

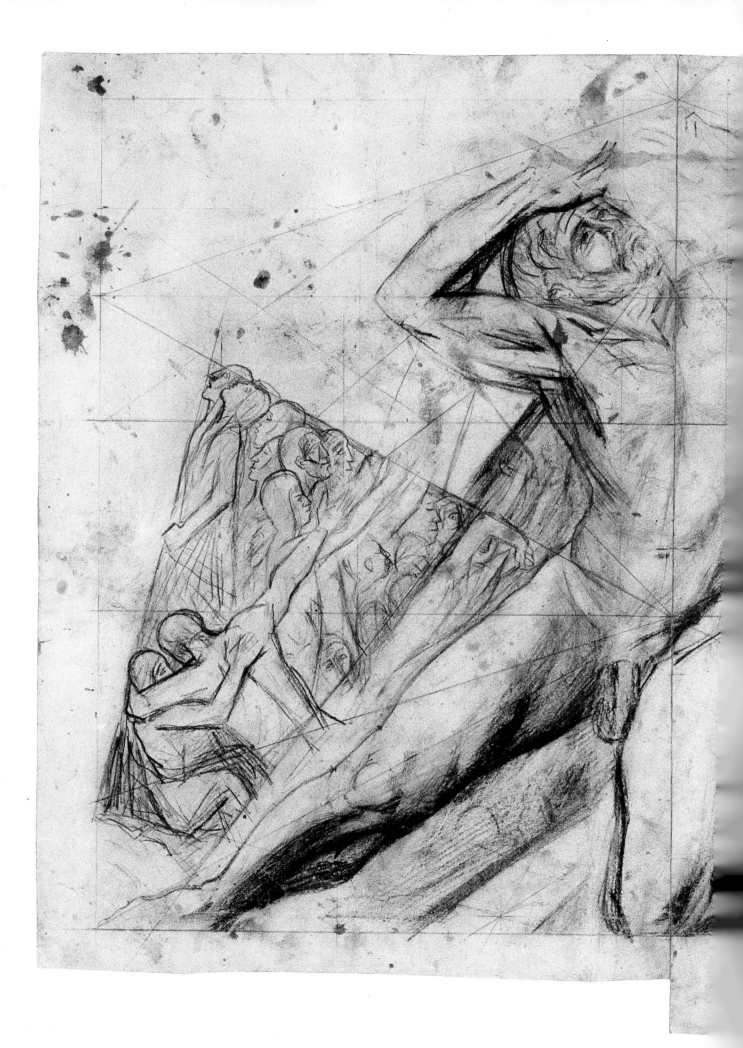

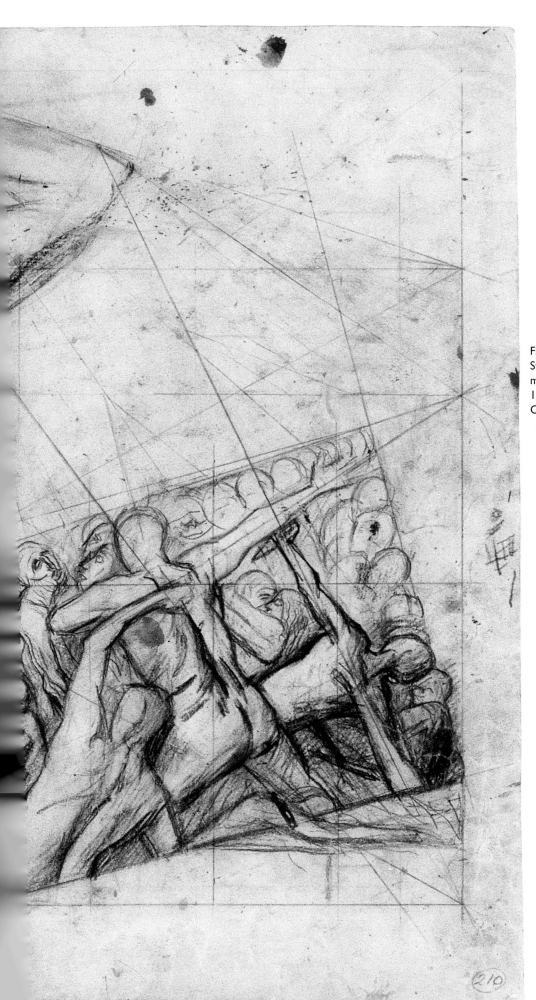

Fig. 56. José Clemente Orozco,
Study for central panel, *Prometheus*
mural, 1930, graphite on paper,
17 5/8 x 23 3/8 in., Pomona College,
Claremont, California (P2000.2.1).

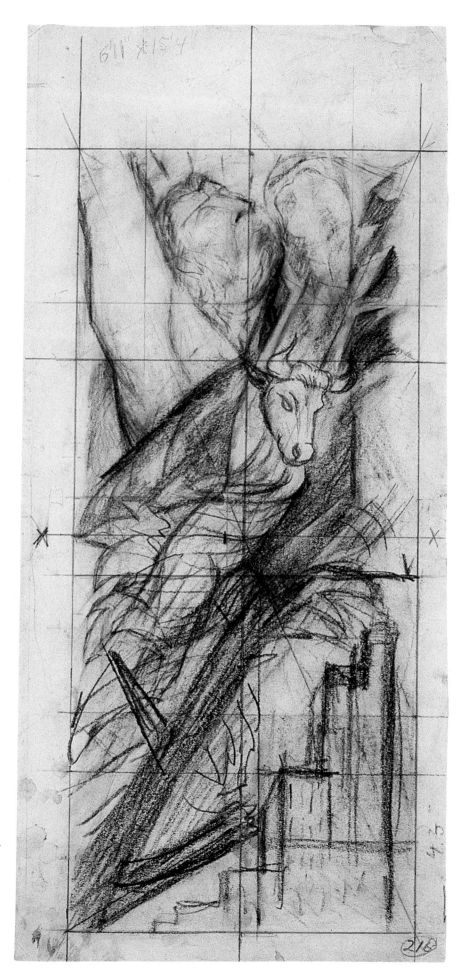

Fig. 57. José Clemente
Orozco, Study for west
panel (*Zeus, Hera, and Io* or
*The Destruction of
Mythology*), *Prometheus*
mural, 1930, graphite on
paper, 13 3/8 x 6 1/2 in.,
Pomona College,
Claremont, California
(P2000.2.3).

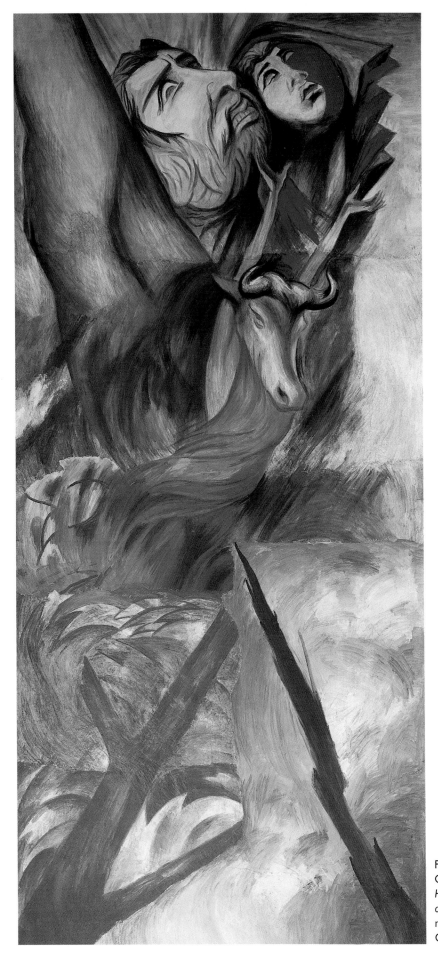

Fig. 58. José Clemente Orozco, west panel (*Zeus, Hera, and Io* or *The Destruction of Mythology*), *Prometheus* mural, 1930, Pomona College, Claremont, California.

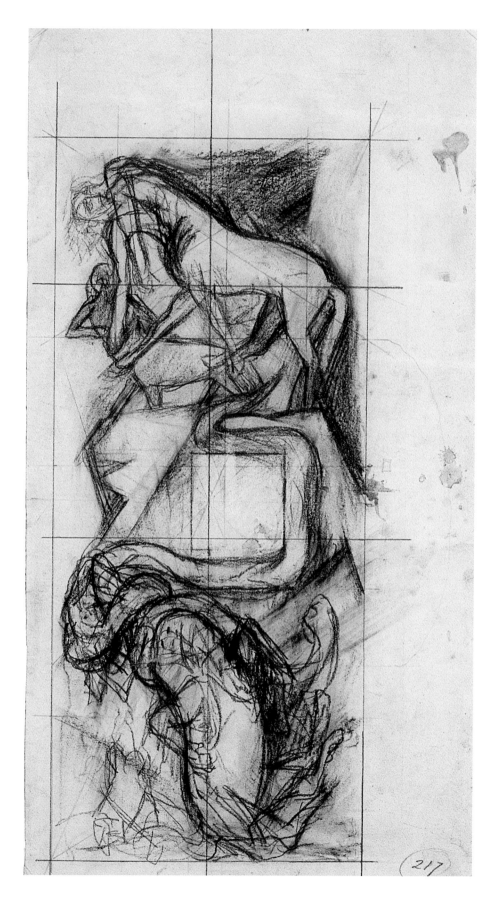

Fig. 59. José Clemente Orozco, Study for east panel
(*Centaurs in Agony* or *The Strangulation of Mythology*),
Prometheus mural, 1930, graphite on paper, 13⅝ x 7⅝ in.,
Pomona College, Claremont, California (P2000.2.4).

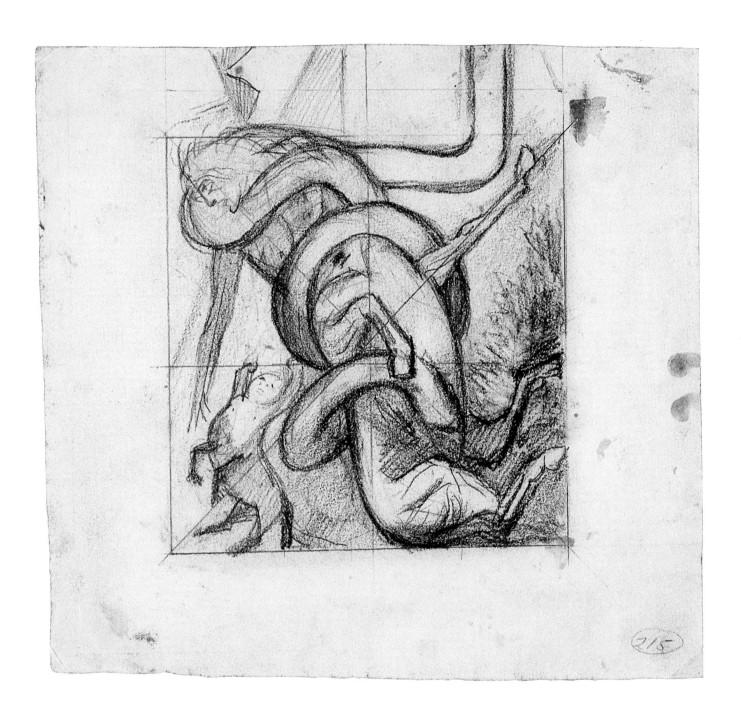

Fig. 60. José Clemente Orozco, Study of centaur and baby
for east panel (*Centaurs in Agony* or *The Strangulation of
Mythology*), *Prometheus* mural, 1930, graphite on paper,
8 x 8¹/₂ in., Pomona College, Claremont, California (P2000.2.5).

Fig. 61. José Clemente Orozco, Study of back of torso with
left arm raised over head, preparatory drawing for *Prometheus*
mural (central panel), 1930, charcoal on paper, 14^{1}/$_{2}$ x 11^{3}/$_{8}$ in.,
Pomona College, Claremont, California (P2000.2.14).

Fig. 62. José Clemente Orozco, Study of leaning figure,
preparatory drawing for *Prometheus* mural (central panel),
1930, charcoal on paper, 15⅝ x 12 in., Pomona College,
Claremont, California (P2000.2.15).

Fig. 63. José Clemente Orozco, Study of torso from
back, preparatory drawing for *Prometheus* mural
(central panel), 1930, charcoal on paper, 16¹/₂ x 12 in.,
Pomona College, Claremont, California (P2000.2.11).

Fig. 64. José Clemente Orozco, Study of arm reaching left
and detail of hand, preparatory drawing for *Prometheus*
mural (central panel), 1930, charcoal on paper, 12 $^7/_8$ x 11 $^3/_8$ in.,
Pomona College, Claremont, California (P2000.2.10).

Fig. 65. José Clemente Orozco, Contour study of torso
and left arm, preparatory drawing for *Prometheus* mural
(central panel), 1930, charcoal on paper, 12 $^3/_4$ x 11 $^1/_8$ in.,
Pomona College, Claremont, California (P2000.2.17).

Fig. 66. José Clemente Orozco, Study of raised right
forearm and fist, preparatory drawing for *Prometheus* mural
(central panel), 1930, charcoal on paper, 11³/₈ x 6¹/₄ in.,
Pomona College, Claremont, California (P2000.2.7).

Fig. 67. José Clemente Orozco, Study of raised left arm with outline of head, preparatory drawing for *Prometheus* mural (central panel), 1930, 11³/₄ x 7³/₈ in., charcoal on paper, Pomona College, Claremont, California (P2000.2.13).

Fig. 68. José Clemente Orozco, Study of two raised arms,
preparatory drawing for *Prometheus* mural (central panel),
1930, charcoal on paper, 12$^{1}/_{16}$ x 9$^{9}/_{16}$ in., Pomona College,
Claremont, California (P2000.2.6).

Fig. 69. José Clemente Orozco, Study for figure with raised left
arm, preparatory drawing for *Prometheus* mural (central panel),
1930, charcoal on paper, 12$^{1}/_{16}$ x 9$^{9}/_{16}$ in., Pomona College,
Claremont, California (P2000.2.16).

Fig. 70. José Clemente Orozco, Study of left forearm and
fist, preparatory drawing for *Prometheus* mural (central
panel), 1930, charcoal on paper, 11 ³/₈ x 13 in., Pomona
College, Claremont, California (P2000.2.8).

Fig. 71. José Clemente Orozco, Study of right forearm and detail, preparatory drawing for *Prometheus* mural (central panel), 1930, charcoal on paper, 11³/₈ x 14⁵/₈ in., Pomona College, Claremont, California (P2000.2.9).

Fig. 72. José Clemente Orozco, Study of head and torso from back, preparatory drawing for *Prometheus* mural (central panel), 1930, charcoal on paper, 14⅝ x 11⅝ in., Pomona College, Claremont, California (P2000.2.12).

1. The Pomona College Museum of Art was, until recently, known as Montgomery Gallery, named for Pomona College trustee and Los Angeles civic leader Gladys K. Montgomery. The change reflects a desire to communicate more effectively the functions of an institution that fulfills the basic mandates of a museum of art—to collect, preserve, exhibit, and interpret works of art—and that houses a substantial permanent collection as well as serving as a gallery for the display of temporary exhibitions. The Museum building continues to be known as Montgomery Art Center.

2. From 1974-93 Pomona College's Montgomery Gallery and Scripps College's Lang Gallery were partners in a joint program known as the Galleries of the Claremont Colleges. Since 1993, the two have been administered independently. The Scripps facility has since been renamed the Ruth Chandler Williamson Gallery.

3. In fact, Orozco did not originally endow the figure with genitalia, as indicated in his preparatory sketch, but added them later. *Prometheus* was painted in "true" fresco, which involves working on wet plaster applied each morning over an area sized for that day's work. The "giornata" lines that delimit each working area remain visible, making it possible to trace the artist's progress across the wall and also to identify areas painted after the surface had dried. The absence of giornata lines in the genital area makes it clear that there was originally no penis. Nathan Zakheim and Aneta Zebala, the two conservators who have worked on the mural in recent years, agree that the organ now visible was added by Orozco using the "secco" technique (painting on a dry surface). Archival records corroborate this. According to contemporary reports, Orozco was aware as he was painting that there were reservations about the mural and concerned that a fully endowed nude figure would meet with disapproval by the College. In an interview in the 1950s, Earl (Fuzz) Merritt '25, who had been director of dormitories and become a friend of Orozco's, recalled being in Frary Hall on the summer afternoon in 1930 when Orozco came to see his mural one last time before leaving for New York. The artist remarked that he regretted leaving the figure without genitals, to which Merritt responded by encouraging him to add them on the spot. Together, they pulled a table and chair onto the stage beneath the mural and, from this precarious perch, Orozco, who had his paints with him, added genitals. The fact that the penis was disproportionate and slightly askew can probably be attributed to the fact that it was painted from below and without benefit of scaffolding, although its timidity might also reflect the artist's concern about propriety. This scenario is confirmed by Merritt's son Jack '39, who heard it told many times before his father died.

4. In 1972, and again in 1976, Gerald Ackerman, chair of Pomona's art department, with the help of other art faculty, touched up areas of damage using pastel chalks that could be easily removed. On several occasions, Ackerman alerted the College administration about the widely held belief among students that Orozco's work had been censored and strongly advised professional conservation attention.

5. Karen Cordero Reiman, "*Prometheus* Unraveled: Readings of and from the Body. Orozco's Pomona College Mural," *José Clemente Orozco in the United States, 1927-1934* (New York: Hood Museum of Art and W.W. Norton & Co., 2002).

6. David Scott, author of the first two essays in this volume, was, at the time, on the faculty of Scripps College in Claremont. He has recently donated his extensive archives, including a copy of this letter, to the College.

7. *José Clemente Orozco: An Autobiography*, translated by Robert C. Stephenson (Austin: University of Texas Press, 1962).

8. It is not entirely clear how many preparatory drawings for *Prometheus* are extant above and beyond these seventeen. In 1992, I saw four in the collection of John Goheen '29 who had posed for the head of the Titan. Goheen told me that the artist had offered him other drawings as well and that he had come to regret his reluctance to accept them. Goheen has since died, and we have been unable to determine the whereabouts of his collection. Laurance P. Hurlburt reported in his book *The Mexican Muralists in the United States* (Albuquerque: University of New Mexico Press, 1989) that Orozco's assistant Jorge Juan Crespo de la Serna owned two preparatory sketches, and that Murray Fowler, the young professor who was Orozco's roommate in Clark dormitory, had yet another. The present location of these three is also unknown. Two drawings belonging to Mr. and Mrs. Earl Merritt, who became friends of Orozco while he was in Claremont, were destroyed in a house fire, and several others have apparently been lost.

9. Reiman, *op. cit.*

10. See Contributors, p. 111.

Contributors

Mary K. Coffey is assistant professor and faculty fellow in the Museum Studies Program, New York University. From 1999–2001, she taught art history at Pomona College.

Miguel Angel Corzo is president of The University of the Arts in Philadelphia, Pennsylvania.

Gerardo Estrada is Director General for International Cultural Cooperation, Ministry of Foreign Affairs in Mexico City. Previously, he was director of Mexico's National Institute of Fine Arts.

Renato González Mello is professor of contemporary art at the National Autonomous University of Mexico in Mexico City. He is guest curator of the exhibition "José Clemente Orozco in the United States, 1927–1934," organized by the Hood Museum of Art, Dartmouth College, in collaboration with the Museo de Arte Álvar y Carmen T. de Carrillo Gil and the Instituto Nacional de Bellas Artes in Mexico City.

Marjorie L. Harth is director of the Pomona College Museum of Art and professor of art history

David W. Scott is a scholar and painter who lives in Whitehaven, Maryland

Translations by **Vicky Daher**, **Charles Daher**, and **Margarita Nieto**, Los Angeles.

© 2001 Trustees of Pomona College

ISBN 0-915478-74-9

Distributed by University of Washington Press

José Clemente Orozco: *Prometheus*

was produced by Perpetua Press, Los Angeles and Santa Barbara
for the Pomona College Museum of Art

Designed by Dana Levy
Edited by Letitia Burns O'Connor
Printed in Hong Kong by Toppan Printing Co.

COVER: José Clemente Orozco, Study for central panel, *Prometheus* mural,
1930, Pomona College, Claremont, California

BACK COVER: José Clemente Orozco, *Prometheus* mural, central panel,
1930, Pomona College, Claremont, California